Paint, PLAY, EXPLORE

EXPRESSIVE MARK-MAKING
TECHNIQUES IN MIXED MEDIA

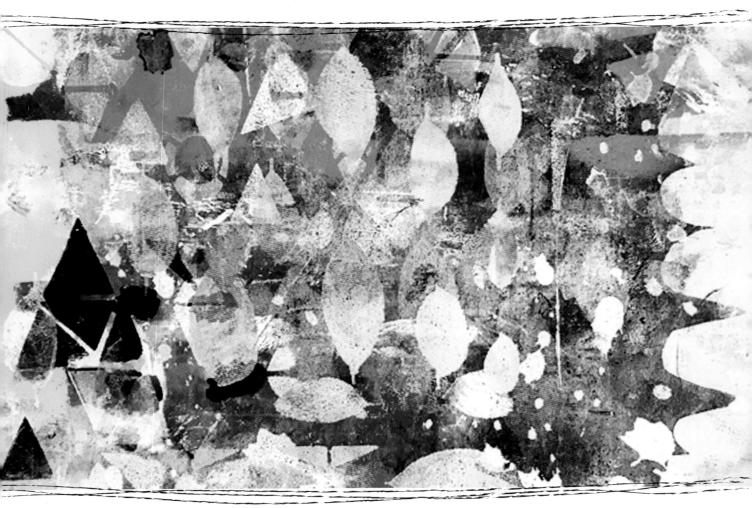

Rae Missigman

NORTH LIGHT BOOKS

CINCINNATI, OHIO
artistsnetwork.com

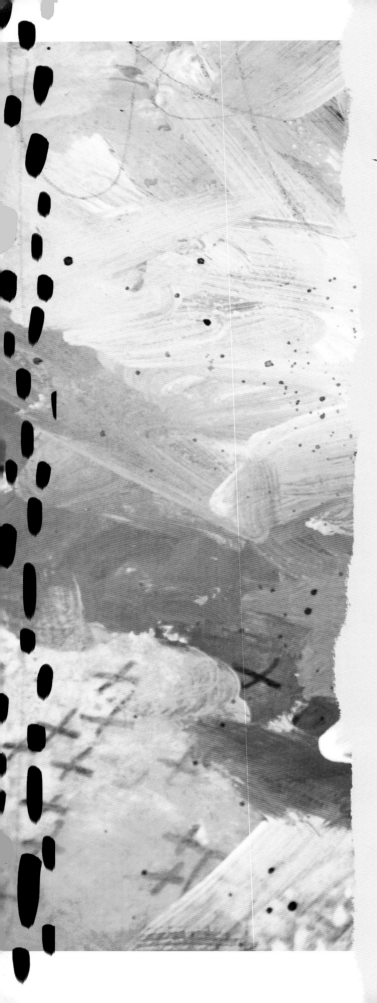

Contents

4

Collect, Tinker, Explore

A fingerprint is a distinctive mark that identifies you as an individual. It separates you from the rest of the world, allowing you to claim for yourself that which makes you unique. Like a fingerprint, the impression you leave behind when you create is a clear and simple way to leave a deeply personal mark within the art world, if you are open to the possibilities.

Opportunities surround you to insert a bit of yourself in the work you create, but first you must collect, tinker and explore. Gathering a variety of implements and shaping them into the tools you need can be both gratifying and enlightening. Collect what you love and think outside of the box. Tinker with your tools and uncover their workings and limitations. Explore what you can do as an artist with tools in hand. Mold your tools into something that defines you as unique.

When your tools are gathered, you'll begin to make your mark. Part of the creative process is doing what you love. For some that will mean the steady hand of repetition—slow and soothing—for others it will be the chaos of eyes wide shut, brush to canvas. The shapes you choose to etch into your work, free-flowing and heartfelt, are a part of what makes the art your own. Tools in hand, your marks will find you and you will begin to recognize yourself in your creations.

Beautiful and moving pieces often begin with a solitary mark, a singular fingerprint on canvas. How you choose to build upon that fleck is up to you. Stacked and hidden or in plain sight, threaded together these become your methodology. All you have to do is claim it as your own.

Art Marks: A Love Story

A SINGLE MOMENT IN TIME CHANGED THE WAY I CREATED.

Believe it or not, my years-long love affair with art marks (my name for mark making) began with a single digit, and I wasn't even making art when it happened. The event that introduced me to my sweet friend, repetition, was not a happy one, but it served to open up a line of communication between my heart and my mind that changed me forever.

That one unhappy moment in time seemed to be swallowing me whole, and I needed a way to get through it. I told myself that if I counted to one, made one mark, I would be one moment closer to the event being in the past. And if I could make it to two then I would be twice as close to making the entire event a memory. And so it went. I counted. And then I counted and counted and counted. Soon that one moment was behind me, and I was rebuilding my life and reshaping my heart to be whole again. The entire process of making marks was a coping mechanism, and while it seemed odd at the time, it worked for me. I learned in that moment that this was a way to comfort my mind, my heart, my soul. All I had to do was count.

THE PURPOSE OF ART IS WASHING THE DUST OF DAILY LIFE OFF OUR SOULS

Finding art came later, and my love of mark making fell into place like a long lost friend. The art made me happy. I was creating everything in saturated color, something that was freeing to me as I surrounded myself with a studio of white. I gravitated to anything that presented itself as a pattern. I never really worried about the rules of the art game; I allowed myself to explore without boundaries and found that my unchecked experiments often resulted in collections of works that were unique and interesting and full of life.

Repetition in my art allowed me the opportunity to create in a way that quite literally calmed me. Tiny dots, dashes and lines were my own crazy way of sorting out the chaos of my daily life. But it was more than the act of making the marks that helped shape me into the artist I am today—it was the story behind the marks.

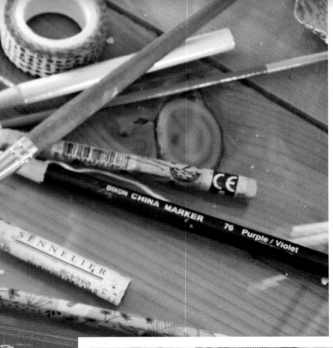

The art I created in the past didn't always clearly reflect the marks that made their way into my work. Like my story, I kept them hidden, buried beneath layers of paper and paint and ink. They weren't to be shared. These marks, to me, were signs of weakness and vulnerability that were better kept concealed. On the surface the art was bright and happy. I never dreamed of sharing the marks that had left such deep scars on my life as a woman, as a mother and as an artist.

But time has a way of altering our perspective on all things. I found myself in art and not just in painting or art journaling. I began a long slow walk through many art forms and found that each time I experimented, I circled back to mark making.

When I stitched, it was in long repeating lines. When I painted, the surface was veiled with symmetrical patches of color. When I worked with textiles, my patterns were variations of reiterated marks and color. Time and again those hidden marks, all born from the silent act of counting, were making themselves present in my work. And still I ignored them. I pushed the marks aside and made something else the star of my work. The color, the pattern or the words—but never the marks.

It was years before I realized that all of the paint and ink layers were just filler for me. They were beautiful, but it was really the marks that made me happy when I sat down to create. I was happy and I was grateful. I was grateful for the act of creating. I was grateful for the art and the process and how it made me feel. The art marks were a major part of that process. I realized, too, that I was spending a huge amount of time covering up those small details that I loved so much. But I was still afraid to make those marks, and all they stood for, front and center.

I was afraid of the questions that would arise. Why marks? What do they represent? What do they mean? Why do they play such a major role in your artwork? I wasn't prepared to answer those questions, but I knew in my heart that I really just wanted to make the kind of art that made me happy.

And then one day I was wandering through a museum, enjoying all of the beautiful and interesting art, and it occurred to me that I wasn't questioning the artist at all. I was just happy to be able to feast my eyes upon his collection. That was the day I decided to stop questioning myself.

That day I changed my focus as an artist. I still created in layers, but now color and pattern no longer served as a disguise. Instead they were centered around the countless marks that found their way into the forefront of my work. I still counted, but now I experienced a new kind of happiness as I created.

I think the art marks were always a part of who I was as a person; it just took me a very long time to discover that they were less a product of endured tribulations and more a result of reshaping myself in the face of life's trials. I learned to embrace the art marks for what they offered me as an artist— a creative outlet. I learned to accept the art marks for what they represented to me on a personal level—a reminder.

And so, with my beloved art marks in tow, I began to see myself as more than someone who dabbles with paint and ink. I found ways to inspire myself that were unique to who I was and what I wanted to convey in my artwork. I surrounded myself with the little things that encouraged and uplifted me in my everyday life. I am a firm believer that if you surround yourself with things or ideas or elements of nature that make you happy, you will feel inspired. Inspiration paired with mark making was the key to creating art that made me happy.

I learned to ignore the Internet and, instead, lift my eyes to the much smaller, more tangible world that surrounded me. I borrowed lines and color from leaves and petals, and I found patterns in the everyday details of home life—fabric, pottery and metal wares. I ignored the cravings for the latest and greatest supplies and alternatively sought after recycled and repurposed elements to use as my mark makers. I learned to mix color, to layer texture and to let my heart guide my paint-brush. And I learned to trust myself.

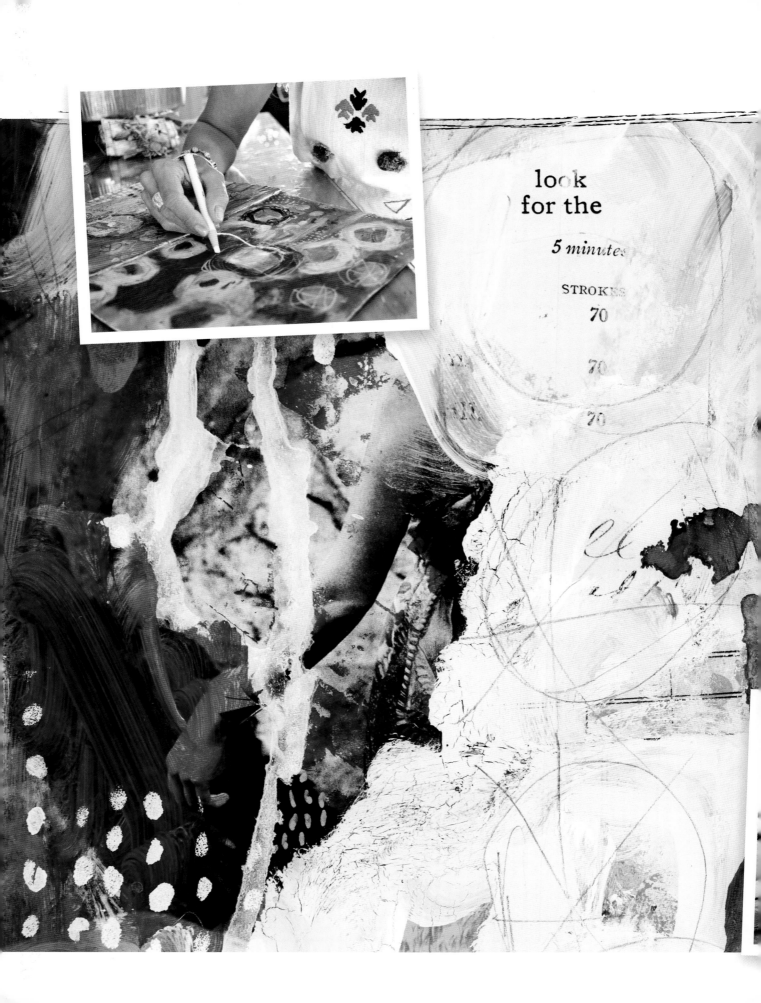

look
for the

5 minutes

STROKES
70

70

70

Once I had accepted who I was as an artist—a mark maker—I began to feel more comfortable in my own skin. I worried less about what everyone else thought and more about what felt right when I created. I focused more on the love affair I had with mark making and less on the end result. And I ignored the rules of the art game. I was creating because it made me happy, not because there was a nail on a wall somewhere calling my name.

My ideas and explorations didn't always lead to successes, but they kept my creative work honest and authentic, just as my failures kept me coming back to the drawing board. Trial and error has always been a part of who I am. As a woman and a mother I expected failure; as an artist I was ensured of failure; as a rule-breaker I was guaranteed to fail. But in failing, I also blossomed and grew and morphed into someone I fully recognized as myself. By embracing my shortcomings I found a deeper, less transparent layer of myself that I was willing to share with the world.

I think that's when I really began to leave my mark on the world, when I began to share. In sharing I found a deep sense of personal happiness because the lines of communication were split wide open. Finally I was able to connect with others who had buried their own version of marks underneath all the pretty that makes up the surfaces of the artworks we put out there for the world to see. I found a great sense of release in the repetition and practice of mark making.

But practice is often difficult. We tend to push it aside to work on those things that come easy, those things that we have mastered, those things that make more sense to us. I dedicated time to the straightforward tasks of both practicing what I enjoyed and digging in and doing the difficult parts. Mark making might have calmed me, but it was still a part of the art I was creating, and with that came the need for practice. I was committed to growing and stretching as an artist, and that meant taking my craft and turning it inside out. It meant examining it under a microscope. It meant breaking it down and building it back up again to be different and better and unique.

I loved the experimentation. As rudimentary as marks can be, they offered me an element that I could take and make my own simply by weaving them into my own artwork in new and interesting ways.

A lot of days I sit in the studio and flip through my journals, searching for that next new spark of originality. I look for inspiration in page after page of practice pieces. Sometimes I get lucky and find a page of vintage graph paper that has a few typed words on it: Just Love. Those two words remind me that I can choose to just love the process; I don't have to love the end result. And no one else has to love it at all. Just me. When it comes to art, for me, the bottom line is this—the end result doesn't always matter so much; sometimes it's just about the practice and the experiment.

My artistic journey has been one of great learning and even greater failure. Along the way I have felt both emboldened and disheartened, but the one constant was always art marks. Without even realizing it, I fell in love with them a long time ago. They soothed me and, in a way, saved me, and now those small marks are what make me the happiest when I sit down to create.

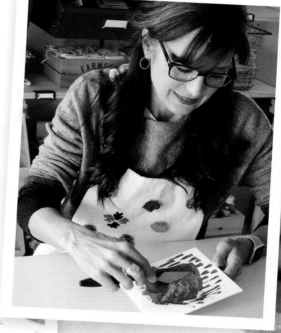

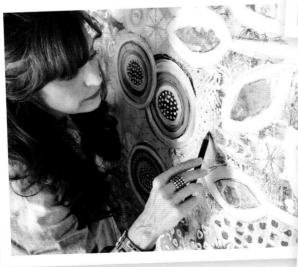

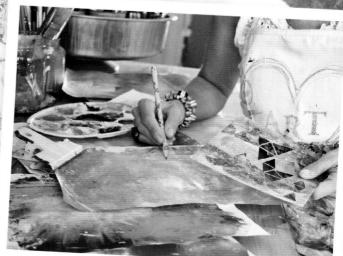

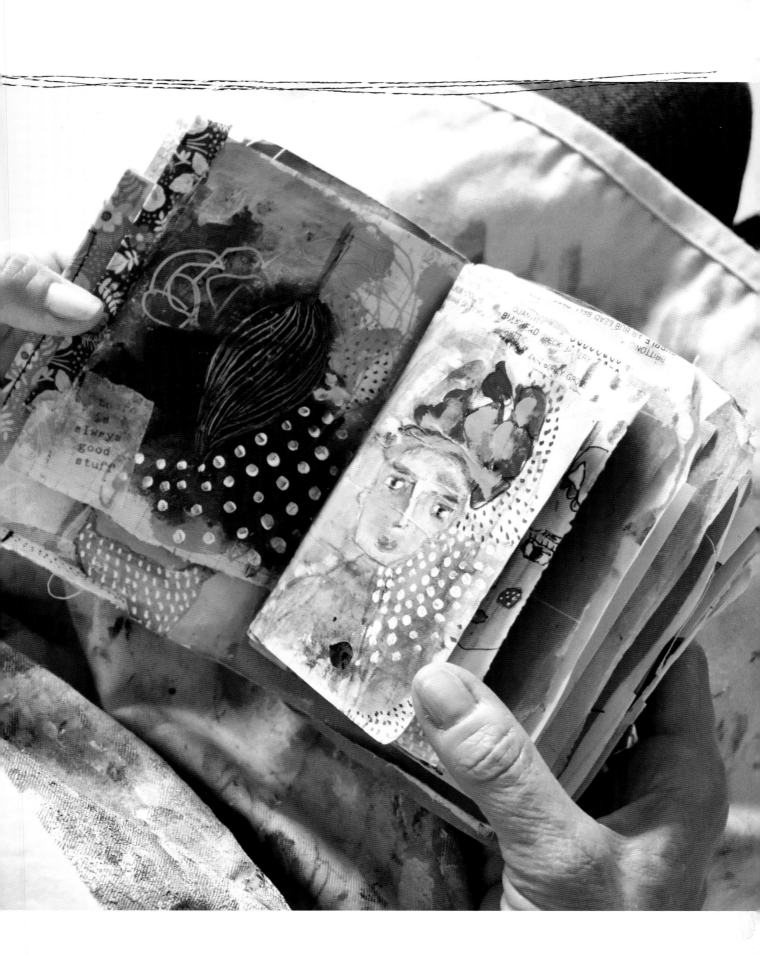

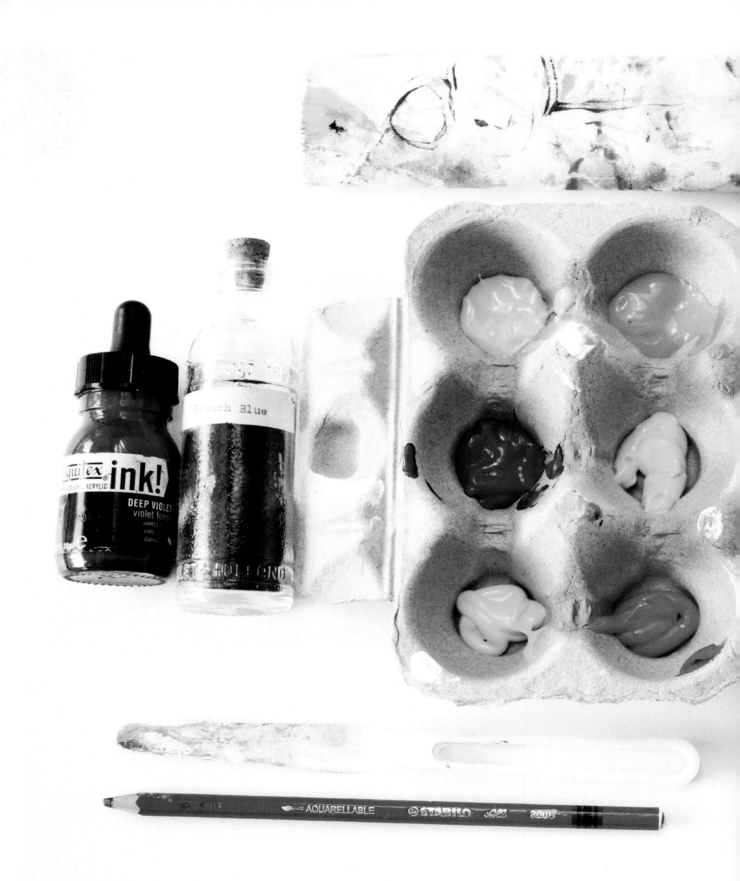

The Tools
THINGS THAT LEAVE A MARK

To be a mark maker is to declare your love of all things that leave a visible imprint or outline on something. To be a mark maker is be a collector of tools, both traditional and nonconventional, that will become an extension of who you are as a marker of art marks. As a mark maker you will become a tinkerer. You will inspect, explore and study your tools and what they can do for you. To be a mark maker you will reinvent the way your art is created, adding and subtracting along the way, remaking something ordinary into something extraordinary. As a maker of marks you will seek to discover your own representations in art, forming and shaping your individual style of imprints along the way. You will find yourself selecting and sorting a unique set of tools that will speak to who you are as a maker of art marks.

Writing Implements

EACH OF THE MOST BASIC MARK-MAKING TOOLS— pens, pencils, crayons, markers and ink-filled brushes— offer their own unique fingerprint when it comes to forming fundamental marks. These simple writing elements are easy to gather and provide you, the artist, with limitless opportunities for forming and shaping marks on a variety of substrates.

As you experiment with these uncomplicated tools, you will discover their individual natures: some are flexible and yielding, allowing you to create outside the bounds of their intended use; others are unbending and less manipulative in what they will allow you to render.

Exploring these tools is key to mastering what they will do for you as an artist. Practice and play with each implement, stretching the limits of its intended use. Dedicate a journal to making notes on all your mark-making tools. Observe how your writing implements respond to water, paint and other mediums. Test them on all varieties of substrates and make notes so you can track what each tool does and how it reacts when paired with other elements. These rudimentary tools are the ones you will most often reach for when making your mark.

» **GRAPHITE STABILO ALL PENCIL**
Water-soluble with intense color, writes on most surfaces

» **DERWENT INKTENSE BLOCK, SHERBET LEMON**
Intense color, can use wet or dry, permanent when dry

» **NO. 2 MECHANICAL PENCIL**
Blendable, erasable, writes over most mediums

» **BLACK CHINA MARKER**
Waxy, water resistant, writes on most surfaces

» **WOODLESS COLORED PENCIL, ORANGE**
Smooth pigmented color, blendable

» **YASUTOMO SUMI INK PEN, BLACK**
Opaque, highly fluid, water resistant

» **UNI-BALL SIGNO GEL PEN, WHITE**
Archival, water resistant

» **BLACK PERMANENT MARKER**
Alcohol-based, permanent

» **AMERICAN CRAFTS METALLIC MARKER, COPPER**
Opaque color, waterproof

» **CARAN D'ACHE NEOCOLOR II WATER-SOLUBLE CRAYON, JADE**
Great pigment, reactivates with water

» **LIQUITEX ACRYLIC PAINT MARKER, WHITE**
Opaque color, waterproof

» **PORTFOLIO OIL PASTEL, PINK**
Soft, smooth, blendable

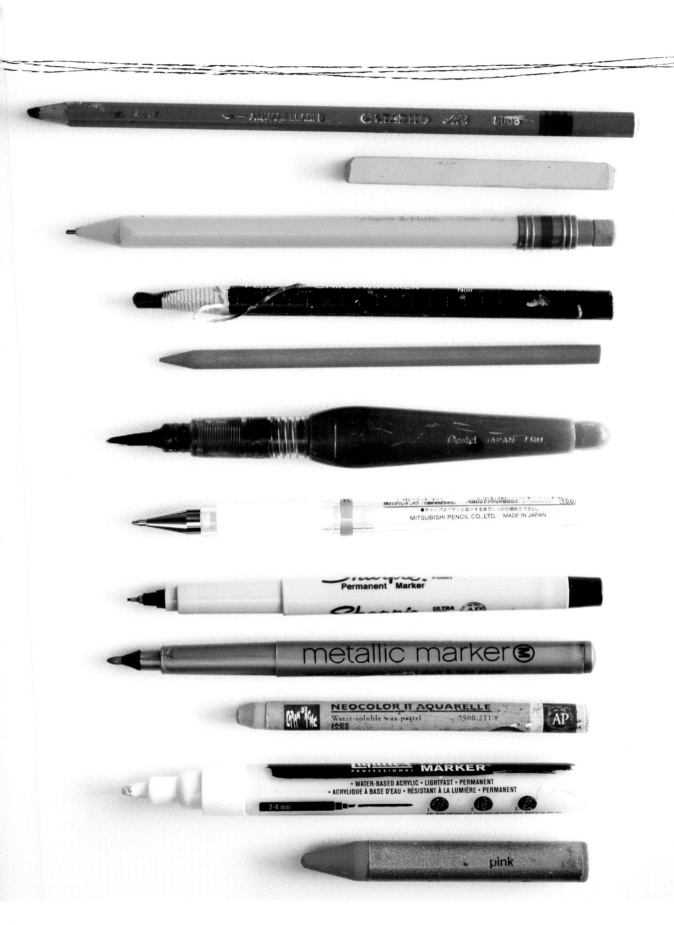

Paintbrushes, Palette Knives & Brayers

PAINTBRUSHES, PALETTE KNIVES AND BRAYERS are all great tools for creating interesting marks that leave a lasting impression. Each of these instruments allows you to manipulate the mediums you are working with, resulting in unexpected and compelling effects. Collect and experiment with an assortment of these tools before delving into a new project.

Having a wide variety of paintbrushes with assorted head shapes and sizes will ensure you have just the right tool to create specific marks as you work. Wide soft bristles, short dense hairs and broad sweeping arcs all have the power to move a piece in a new direction.

Palette knives bring dimension to the table and are indispensable when it comes to building texture and adding a unique sense of flavor to a piece of art. Choosing the right knife is requisite to adding a specific finish to a piece. Small, rounded blades are perfect for adding paint to small areas while wide, flat tips are best for spreading smooth, even texture to a large surface. This simple and age-old tool is the one that will take your art to the next level by cutting, etching and dividing areas of the piece into beautiful and interesting levels of depth.

When searching for a true workhorse of a tool, you will need to look no further than your brayer. It has the power to spin a full and impactful background on a large work in a short amount of time as well as roll the final touches across your piece, suddenly and fully bringing it to life.

Work with these tools and make notes in your journal. Which ones feel good in your hand, are easy to handle and give you the desired results? Which ones will require a bit of handling to become an extension of you, the mark maker? The staples of any artist's toolbox, you will find these implements to be the faithful laborers that build beautiful foundations over and over again.

» RED DETAIL BRUSH
No. 0, synthetic, round

» GREEN LONG HANDLE
No. 6, bristles, round

» SMALL BRAYER
Ultra soft rubber, footed stand, 2¼" (57mm) wide roller

» DECORATIVE BRAYER
1¾" (44mm) wide roller

» TROWEL PALETTE KNIFE-STRAIGHT PALETTE KNIFE
2⅜" (60mm) and 3¾" (10cm) plastic, washable, lightweight

» OVAL WASH BRUSH
1" (25mm) rubber grip handle, soft bristles

» SHADER BRUSH
½" (13mm) flat shape, angled edge, synthetic fibers

» FAN BRUSH
no. 2, durable synthetic nylon fibers

» CHIP BRUSH
1" (25mm), great for laying thick layers of paint or gesso

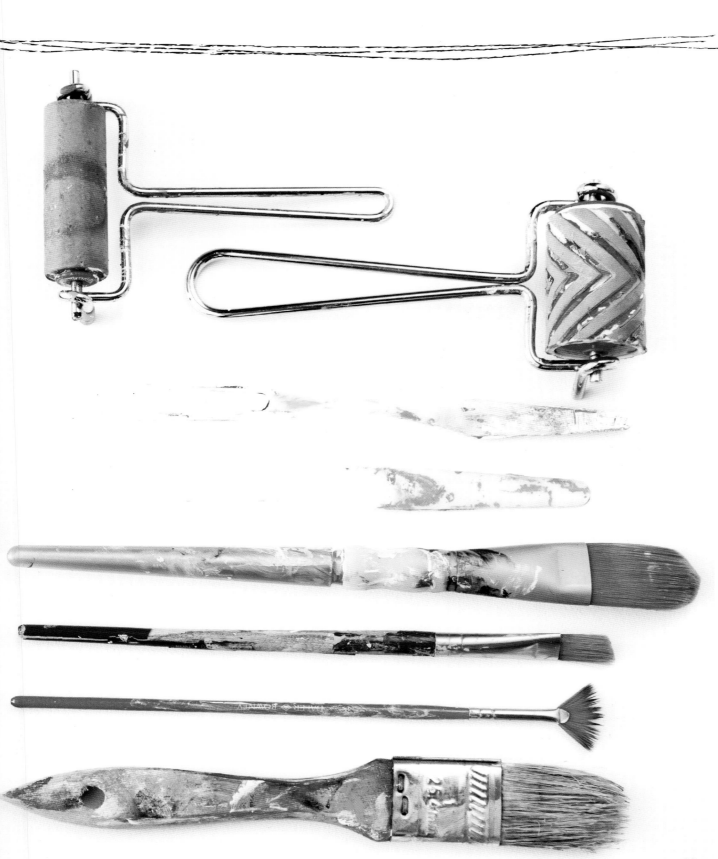

Fingers & Hands

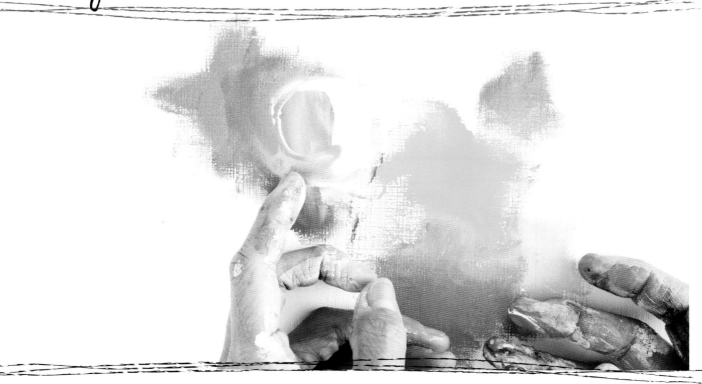

THERE IS SOMETHING VERY PERSONAL AND PROFOUNDLY EXPRESSIVE about painting with your fingers and hands. The root of all artwork and a practice that dates back millions of years, finger painting allows you to create at a basic level. While seemingly simplistic in nature, this practice allows for the greatest control when placing marks on or within your work. Without the added extension of an outside tool, your fingers and hands allow your marks to be added in both a fluid and defined manner. In creating with these take-along tools, you will find that using your hands and even your lower forearms can add an unexpected and delightful layer to your work.

Think of your hands as a built-in brayer, allowing you to move paint and other wet mediums across the surface of your canvas quickly and in large sweeps. The results are both surprising and unique: Each artist's hands leave their own distinct texture behind in their wake. Just as your hands are a brayer, your fingers are your brushes, varying in size and shape and each leaving a detailed and unique mark with each stroke. Controlling your medium is straightforward with the use of these fundamental tools. From coverage to placement, you will gain a new awareness of what it means to build a foundation that speaks to who you are as an artist.

Begin by doing a short case study in finger painting. Using nothing but your hands, investigate the powers of moving the paint across the page. Experiment with one finger first, then use your whole hand to smooth and blend the colors. Add notes to your journal about the texture and marks that are built into these take-along tools, observing how these tools' fingerprints change as you create on an array of substrates. Immerse your fingers and hands in the paint. (This can be a big hurdle for some artists.) Become familiar with how the different mediums feel on your hands as you work. Do they dry quickly or stain? Do some mediums react poorly with your skin? Be aware of your allergies and note reactions in your journal, steering clear of any paints or mediums that cause irritations. Once you have answered these few simple questions, you will be ready to create some of the most intimate marks an artist can add to a work.

Stamps, Stencils & Masks

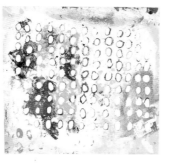

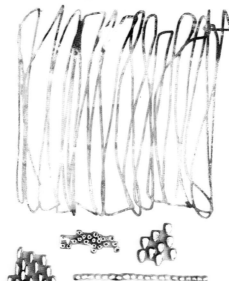

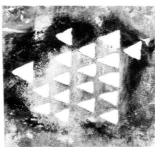

A FAVORITE OF MANY ARTISTS, STAMPS, STENCILS AND MASKS offer an endless lineup of mark-making tools. Both handmade and straight off the shelf, stamps, stencils and masks are easy to add to your toolbox and are easily mastered.

Stamps are typically made of a clear acrylic plastic or red rubber material and have the ability to add specific and planned details to any work of art. You, the artist, have the added benefit of being able to create your own hand-carved stamps. With a variety of materials and instructions available, even the novice carver can create specific stamps. You can harness that power and introduce one-of-a-kind marks simply by using a hand-carved stamp. Combined with inks, paints and other wet mediums, stamps can add interesting color, texture and detail to your work in a short amount of time.

Stencils are also tireless tools. Most commonly made of chipboard or thin plastics, shapes, words or numbers are cut into the material, leaving a void. Because stencils stand up to a huge array of mediums such as paint, ink, gesso, modeling paste and more, you, the artist, can collect and create with an endless supply of premade marks.

A mask is used to protect the surface beneath it and has the potential to create a beautiful negative space in your artwork. Stencils and masks, like stamps, need a counterpart before they can be used to help you make your mark. Sponges, brushes, palette knives and your fingers are all good choices for adding mediums to your work when using these tools.

Stamps, stencils and masks are all indispensable when you are looking to create visible and easy to repeat marks. When adding notes to your journal, consider these points. If you are going to apply paint to your stamps, red rubber is the better choice. Wet and fluid mediums are best used with a plastic stencil. What kind of predesigned marks are you looking to collect in the form of stencils and masks? What size stencils will work best for your projects? Make additional memos on application methods, noting in your journal what works best with specific mediums of your choice.

Paints, Inks & Dyes

PAINTS, INKS AND DYES ARE ALL COLORFUL CHOICES for mediums when working with your favorite mark-making tools. Paints and inks are available in any number of viscosities and when paired with assorted mark-making tools will offer a wide variety of end results. You, the artist, can easily control the application of this medium simply by choosing a specific applicator, such as a brush, sponge, palette knife or your fingers and hands.

Ranging from fluid and transparent to opaque and heavy body to sheer watercolors, paint is a colorful choice. Not limiting yourself to what is available on the shelf but, instead, mixing your own colors to create a unique and captivating palette will help to create artwork that is intriguing and polychromatic. Price points for paint are usually reflective of both depth of pigment and range of coverage that a specific brand will produce.

Inks are similar to paints in that they are available in a wide range of colors and brands. In addition to offering a full range of color options, inks are also found in both permanent and water-soluble formulas. Acrylic inks present pigments that are very intense and opaque while water-soluble inks are sheerer in nature. Both types of inks are fluid, but they can be diluted with water, allowing you to alter the levels of intensity and transparency.

Dyes are similar to inks in that they offer a range of permanent and water-soluble stains. Fabric dyes are highly pigmented and combine special binding agents to make them waterfast and lightfast after the initial dyeing process. When creating, you, the artist, may enjoy the flexibility and unique properties of less traditional dyes, such as food coloring and the small pellets used for egg dyeing.

It is important to get out your journal and test the different varieties of pigmented mediums. Try making a color swatch for each brand and note the name of each color. Consider adding supplementary notes on opacity, water solubility, viscosity, favorite application methods and whether a brand is colorfast or lightfast. Record the results when experimenting with nontraditional dyes. Dyes of an organic nature have a tendency to degrade over time. Consider creating a color swatch and record how the dyes react over a longer period of time, paying special attention to color and lightfastness.

» ROW 1
Golden Fluid Acrylic: Quinacridone Magenta, Quinacridone Red, Transparent Pyrrole Orange, Diarylide Yellow, Green Gold, Teal, Ultramarine Blue, Payne's Gray

» ROW 2
Golden Fluid Acrylic: Alizarin Crimson Hue, Quinacridone Nickel Azo Gold; Liquitex Soft Body Acrylic: Hooker's Green; Golden High Flow Acrylic: Turquoise; Golden Fluid Acrylic: Dioxazine Purple; Liquitex Soft Body Acrylic: Mars Black

» ROW 3
Golden Heavy Body Acrylic: Titanium White; Master's Touch Heavy Body Acrylic: Ocean Green, Olive Green; Amsterdam Standard Series Acrylic: Reflex Rose; Golden Fluid Acrylic: Raw Sienna; Martha Stewart Acrylic Metallic Multi-Surface Paint: Brushed Bronze

» ROW 4
Liquitex Acrylic Ink: Pyrrole Red, Cadmium Yellow Light Hue, Sap Green, Permanent Prussian Blue Hue, Quinacridone Magenta, Deep Violet, Dioxazine Purple

» ROW 5
Shinhan Watercolor: Crimson Lake, Permanent Rose, Cadmium Yellow Orange, Greenish Yellow, Veridian Hue, Light Red, Indigo, Peacock Blue, Permanent Violet, Opera Pink

» ROW 6
Paas Dye Pellets: Purple, Yellow, Blue, Green, Orange, Pink

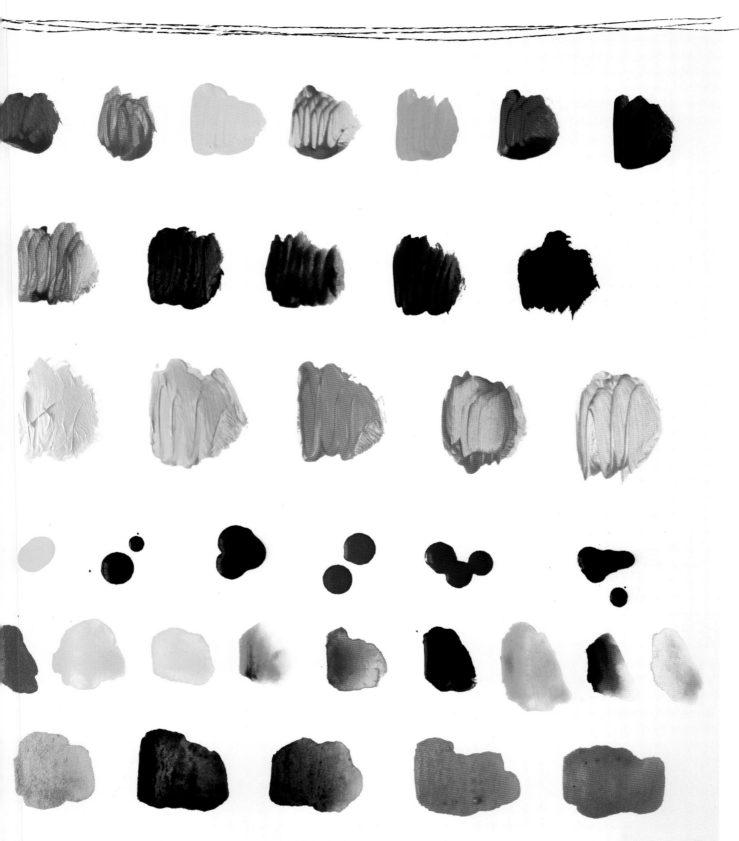

Primers, Pastes & Resists

PRIMERS, PASTES AND RESISTS ARE MEDIUMS THAT PRESENT NO VIBRANT color. Like paint and ink, however, they do come in a range of viscosities and can be used to create interesting negative spaces and build texture and dimension in almost any work of art. Before incorporating primers, pastes or resists into your artwork, study them and consider creating an entry for each one in your journal. Test each medium on different substrates and record how they react with paints, inks and other mediums both as a foundation layer and as a layered component while working through a project.

Gesso is most often used as a primer. Typically it is applied to paper, canvas, wood or other substrates and adds a bit of tooth to the foundation. Gesso, like most mediums, comes in both student and professional grades, with the main difference being the amount of filler used in the gesso. The most popular color choices are white and clear, though gesso can also be found in black and a range of other colors. Gesso can be easily tinted by adding a bit of paint or ink and mixing well. Because it is primarily used as a primer, gesso is found in a variety of textures, such as coarse, extra coarse and smooth. Working with a sample of each type in your journal is a great way to explore which options work best for your unique style of artwork. Try creating a swatch palette of different textures and grades. Add color to tint and explore the results of working on nontraditional substrates such as fabric and wood.

Modeling paste is a white opaque acrylic medium that allows you to add controlled amounts of texture to your artwork. It, too, can be used as a primer, but it is best for adding stiff peaks and definable dimension to any number of substrates. When dry, the paste can be sanded to create a smooth finished surface. The paste can be tinted before applying it to your surface, or painted and inked after it is dry. Try observing the different levels of texture and dimension you can achieve when working with different tools such as stencils, masks and palette knives. Note the difference in finish quality when the paste is sanded.

Gel medium is another indispensable tool that can be used to build texture, act as an adhesive and finish and seal a piece. Gel medium ranges from fluid to very heavy body, has a slow drying time, dries translucent and makes a great adhesive for collage and paper projects. During your record keeping, note how the heavy-body gel holds knife and brush marks while a more fluid medium increases the "flow" of paint when used as an additive.

Resists are another great supply to have in your toolbox. Both masking fluid and rubber cement can be used to "mask" off specific areas of your work to protect underlying layers. One common difference is the viscosity. Masking fluid is very thin and can be applied to specific areas using a detail brush. Rubber cement is thick and goopy and will work better for masking larger areas. Both types of resist are easily removed using a pickup tool or by gently rolling your fingers over the dried resist areas.

Another great resist tool is a simple wax-resist stick. Think about adding a swatch palette to your journal using both translucent and colorful wax crayons with your favorite watercolors. This is a great reference when you are looking to achieve a certain look with your resist and paint colors.

» WAX RESIST STICK (PAAS) (TOP ROW)

» MODELING PASTE, WHITE GESSO, GEL MEDIUM (HEAVY BODY, MATTE), RUBBER CEMENT, MASKING FLUID (BOTTOM ROW)

Substrates

Substrates are the key ingredient to an art piece—the foundation on which all of your marks will be built. When choosing a substrate for a project, you will want to do a trial run and have your journal ready to record the specific components of working with each one. Consider gathering small pieces of each substrate you might want to work with. Apply combinations of paints, inks and resists, along with pens, pencils and markers, to get a better understanding of how each substrate reacts as a base for your artwork. While doing your trial observations, note that papers of all kinds will be the weakest substrates and may require a special treatment before layering your mediums. Gesso is a great way to add some tooth and durability to your paper substrate before beginning.

While watercolor, bristol and mixed-media papers are all great for working with wet mediums, there are some nontraditional papers, such as file folders, that also make interesting foundation substrates. Once tested, add your small swatches to your journal to use as a reference when

>> **MANILA FILE FOLDER**

>> **RECYCLED BRISTOL PAPER (CANSON)**
Vellum front surface/smooth back surface

>> **CANVAS FABRIC**
Heavy cotton duck cloth, close weave

>> **COTTON MUSLIN FABRIC**
100% cotton, bleached white

>> **CANVAS PANEL**
Acid free, archival quality, 5" × 7" (13cm × 18cm)

>> **NATURAL DRIFTWOOD CHIPS**

considering which paper to select while working on a project.

Fabric is another interesting choice for a substrate. Canvas and duck cloth are both durable options and can be worked on with or without the addition of a primer. Cotton muslin is an interesting but much less durable fabric choice that when primed can be worked over with several layers. Unprimed, this flimsy textile makes a great choice for working with inks and stains. Working with a small swatch, which can be added to your journal for reference, try creating small, layered works both with and without a primer. Once dry, these swatches will help determine how each textile will look and feel. A second set of swatches can be reworked when dry to get a better understanding of how other mark-making tools react when applied to primed or painted material. Painted fabrics are easily manipulated and make great foundation substrates when creating stitched pieces of artwork.

Canvas panels are sturdy boards that can be worked over with any number of mark-making tools and mediums. These panels come heavily toothed and, as a rule, work well without the addition of a primer. Panels come in a wide variety of sizes. A mini 3" × 3" (8cm × 8cm) panel makes a great swatch for your reference journal. When documenting your test on this substrate, consider how each tool reacts to the tooth of the foundation as well as how paints, primers, inks and resists react as layers on the panel.

Wood is another sturdy and workable substrate. Both artist quality and more organic found pieces of wood accept most mediums well and make compelling foundations when creating a work of art. In order to test your substrate, try gathering a mix of both store-bought and found pieces. Small pieces of bark and thin layers of birch wood make great journal swatches and offer a slight variety in foundation color and texture for your experiments. Smooth sanded chips and blocks offer simple store-bought choices for assessing how your mediums and mark-making tools will react to this natural foundation.

Note interesting differences such as absorption rate on the bare timber compared to wood that has been primed with gesso or paint, how simple implements such as pens and markers react to the drag of this organic surface, and drying times between added layers of paint, ink and resists. Each substrate offers something unique when creating and is key to how the finished piece will look, feel and present itself.

Machine & Hand Stitching

THE ADDITION OF STITCHING IN ARTWORK ADDS A UNIQUE AND interesting element of texture. Typically added as a final mark, stitching can be a simple series of hand-sewn French knots or a complex design created with the helpful foot of a sewing machine. When added without design or forethought, hand stitching can add a layer of random and tangible marks, creating a colorful sense of dimension in a piece. When planned, these same marks can bring to life a focal point that is bold and full of dimension.

Hand stitching can be applied to paper, fabric and even a fully worked stretched canvas. Consider practicing an assortment of hand-stitched marks on both paper and fabric, and add the test swatches to your reference journal. Note how variously sized needles react with the differing substrates—papers will require a finer needle while heavy-duty fabrics and a stretched canvas will call for a more durable needle. Explore a medley of threads and yarns and how a finished stitch can vary in size and dimension depending on both the yarn's gauge and the number of strands used to create the sewn mark. Study the effects of twisting multicolored strands to create marbled and multihued marks.

Test the bounds of ordinary sewing by creating layered and oversized stitches. The sewing machine can offer even the most novice seamstress a completely different and singular stitched mark. Whether adding a bold focal point or a wonderfully abstract design, machine stitching adds a tactile layer that is both eye-catching and unique. Allowing the machine to do most of the work, you can move and rotate your fabric or paper substrate, creating the smallest or largest of final layered marks.

When working on small swatches for your reference journal, test out the different stitches available to you on your machine, experimenting with stitch length and width. Create simple patterns like circles and lines before doing a trial run with more complex designs. When cutting your threads, consider leaving them long and loose for added texture.

When you are ready to explore sewn focal points, try penciling your design onto your substrate before beginning to stitch. As you sew, view these sketched lines as a loose pathway to follow rather than a dot-to-dot exploration. The addition of stitching to a work of art is a simply another layer of marks. Considering this as you work, your marks will likely present themselves as more organic and free-form in nature.

Repurposed Tools: BRUSHES, STRAWS, SPONGES & MORE

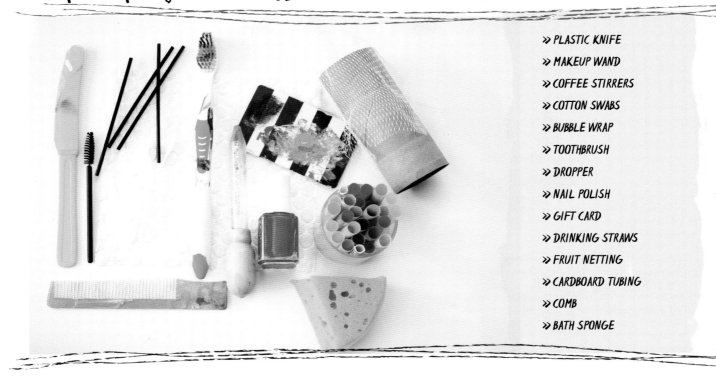

- » PLASTIC KNIFE
- » MAKEUP WAND
- » COFFEE STIRRERS
- » COTTON SWABS
- » BUBBLE WRAP
- » TOOTHBRUSH
- » DROPPER
- » NAIL POLISH
- » GIFT CARD
- » DRINKING STRAWS
- » FRUIT NETTING
- » CARDBOARD TUBING
- » COMB
- » BATH SPONGE

UPCYCLED TIDBITS OFFER A UNIQUE SET OF TOOLS FOR MARK MAKING.

Easy to find, these simple supplies lend an unusual look to a work of art when combined with a variety of mark-making techniques. You can easily create and alter the marks created with such tools.

Reusable instruments such as plastic knives, combs, brushes, straws and stirrers can be used to create the simplest of organic marks, such as lines, circles, dots and scratch marks. Pieces of bubble wrap, cardboard tubing, fruit netting and sponges will each leave an unusual imprint when coupled with the same mediums—smudges, rings, hash marks, peaks and valleys, each mark uniquely different each time they are applied. Cotton swabs, gift cards, droppers and even nail polish all have the ability to create singular marks within a

piece of art. Swipes, stripes, drips and splatters: each upcycled tool creates random yet repetitive marks that cannot be duplicated, only replicated—the beauty of their raw and disposable forms.

Merged with an array of mediums, each of these basic marks will appear differently according to the medium it is paired with when applied to a specific substrate. While paint will leave heavier, toothier marks, inks paired with these tools will leave marks that appear less defined, more abstract and blended. And while the medium itself is core to getting the mark down, the way you manipulate each upcycled tool is where the real sense of singularity comes into play when making your mark.

Each tool will leave a varied impression of itself depending on the application method. Nail polish

can be applied with precision and form specific marks of color, or its wand can be used to spatter the paint across the page in an uncontrolled swathe. An upcycled toothbrush can be used to apply ink or paint in a pattern specific to its head shape, or it can be used to pull and drop the ink across the surface of your work. A sponge can be used to add simple impressions to a substrate, or it can be paired with a watery ink and used to add a wash of color to the entire surface.

Consider these tools and the variety of ways you can approach your foundation when using them, and make notes in your journal. Be generous in your explorations with these tools and dedicate several pages to what they can do for you as an artist when it comes to mark making.

Organic Tools: LEAVES & VEGETABLES

» NORTHERN PINE, WHITE ONION, CELERY HEAD, POTATO VINE, DUSTY MILLER, DRAKE ELM, FOUND TWIG

Organic tools such as leaves, twigs, fruits and vegetables are interesting choices for mark-making tools in that they are truly unique by their very nature. No two leaves, twigs, fruits or vegetables will ever be alike, thus their marks will be one of a kind. These tools can be used in a variety of ways, each offering an uncommon and distinct mark.

Leaves, flowers and vegetables all leave wonderful impressions. Adding paint and ink to these organic implements and using them as stamps is a delicate but rewarding process, leaving intricate and detailed impressions. Sticks and twigs make equally handy mark-making tools. When dipped into wet mediums they can be used to draw or sketch simple, rudimentary marks and add delicate loose details across a foundation.

A popular and gratifying technique that is easily coupled with these simple organic tools is monoprinting. You can create one-of-a-kind layered prints using these living elements as simple masks on a printing plate. With an endless supply of both organic elements and combinations on the plate, the possibilities for pattern and design are endless.

You will want to make lots of notes on these collected tools. Test each one with a variety of inks and paints. Note the viscosities and how they react with the living tool. Make references to the life of the tool once it has been plucked, picked or cut. Record the impression it makes as a stamp or mask in your journal. Layer these tools and always be on the lookout for interesting living tools.

A word of caution: not all living elements make good tools. Always do your homework and stay away from all varieties of plants and flowers that are naturally poisonous or may cause allergic reactions. Consider gathering your organic implements from within the safety of your own garden or yard, or consult a botanical guide before collecting your living tools.

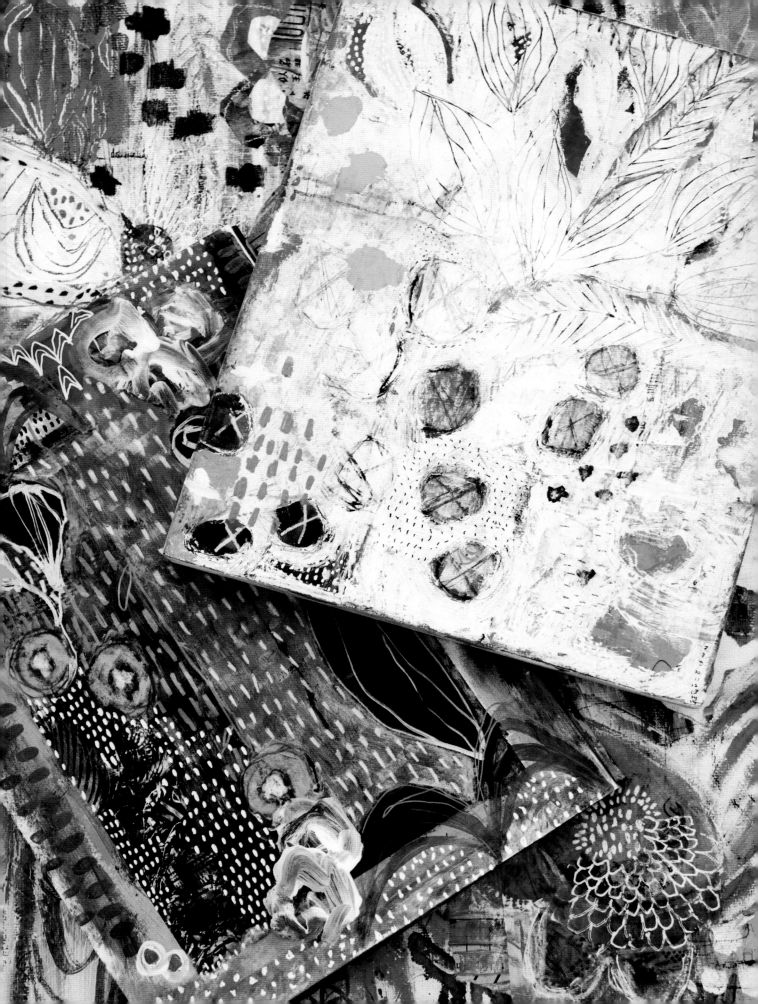

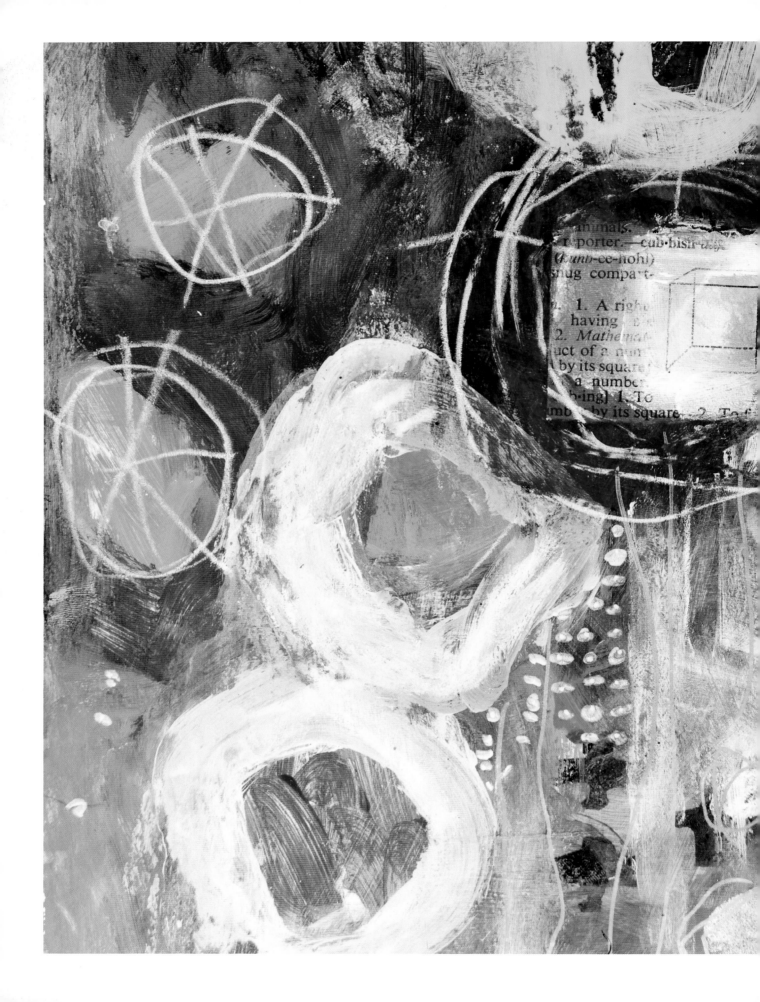

The Marks

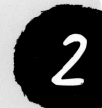

THE FINGERPRINTS OF YOUR ART

Mark making is a core part of any artistic work and yet the simplest to create. Put pen, pencil or brush to paper and you will find that the marks spring forth with little or no prompting, as basic and unique to each of us as penning an alphabet. You may compose the same letters as the next artist, yet if scripted by rote, yours will take on a look all their own. By force of habit you become comfortable with what you are creating, developing a distinct style along the way that is recognized as your own.

Because the mark-making process is primary in nature, it takes little practice to master the foundational marks that others will be built upon. Dashes, dots and hashmarks, while all easily created and replicated, become something of your own when practiced as a matter of course. Any mark made with little thought and fluid movement becomes a mark that is unique in style.

Force of habit is only one part of making marks that are truly your own. Your toolbox is another key component in creating beautiful artistic fingerprints. Even when creating identically formed marks, a wet paintbrush loaded with a fluid medium will leave an imprint that differs greatly from one left with a dry chalky pencil. Similarly, you can form the same marks on either a toothy canvas or a smooth vellum surface and each will produce contrasting results.

The more you test and experiment with your tools, the sooner your mark making will become routine. Once the activity is part of your daily artistic system you will find yourself immersed in the mark making, refining the process until each mark is an extension of your expressive eye. As you become more comfortable with your tools, you will begin to bend the rules of each to make them work for you and make your marks come alive. The simplest of motions unique to you—the way you hold a brush or the twist of your wrist as you work—will make each fundamental mark yours. Make mark making a happy habit; practice, experiment with your tools and do what comes naturally to you as an artist.

Simple Marks

BASIC MARKS ARE BUILDING BLOCKS AND COLLECTIVELY MAKE UP YOUR ALPHABET OF mark making. During the course of practice, you will discover a simple set of characters or symbols that you find yourself repeating over and over again in your work. Once defined, these will be the core of all your future and more progressive marks. If you have any doubts as to what basic marks can lend to a piece, you have only to experiment with them to realize their impact on an artistic creation. Simple can equate to much more when layered among more complex techniques. Whether front and center or part of a subtler layer, fundamental marks have a way of forming their own nucleus in any form of art.

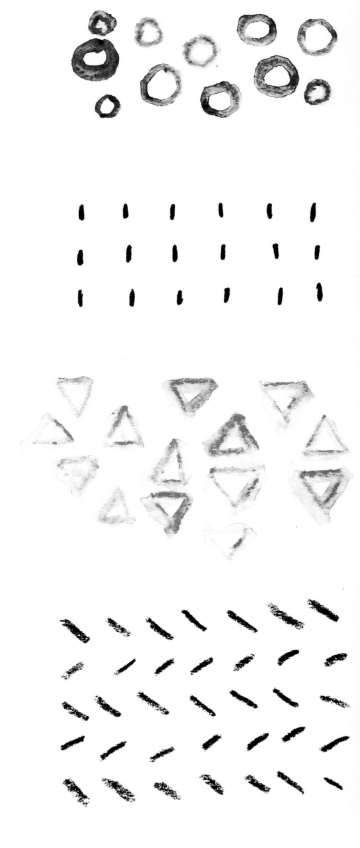

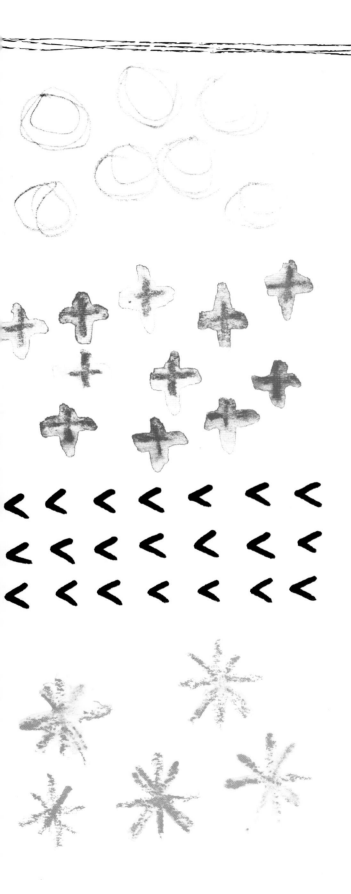

THE BEAUTY OF MARKS IS THAT YOU, THE ARTIST, ARE AT THE HEART OF EACH ONE.

Whether you are creating a fixed pattern or an abstract work, your marks will take on a life of their own with just a handful of variables in play. Make a note of each variable tested, adding sketches to your journal as you play and practice with your mark making. Record chosen tools, speed of application and different types of substrates tested. Your notes should reflect elements that are key to you as the mark maker. Were your marks deliberate and precisely placed or did you close your eyes and blindly let the pencil do all the work? Was a specific medium added into the mix to create marks that were more fluid in nature? What marks did you find yourself creating over and over again?

Your journal will become your companion when it comes to mark making. By keeping a diary of marks, you will easily be able to note what combination of the above variables works best for different genres of creating. Consider the following key elements when you are ready to incorporate mark making into your artwork: repetition, using your fingers and hands, stamps and stencils as larger mark-making tools, and repurposed and upcycled mark makers. Soon you will be viewing the world around you as inspiration for your mark making, taking your collected set of primary marks to the next level.

Repetition

MAKE YOUR MARKS COUNT

Repeating marks can convey a simple or complex pattern, both as a standalone piece of art or within an existing piece. To create mark-making artwork that is interesting in composition, try creating clusters of marks that stand alone as an element in the work, focusing both on odd numbers and keeping the group of marks off center. Even a single mark, odd in numeric value and singularity, can create a stunning focal point.

When building layers with repetitive marks, don't forget to refer to your journal for notes on choice of color and tools. Creating repeating marks in your journal is a great way to experiment with a wide variety of tools and allows you to become more familiar with what each tool can do when creating your foundation marks. Oftentimes the most interesting repeating marks are created with tools that leave less defined imprints, such as water-soluble pens and pencils. You will want to use these in your final mark-making layer to ensure they are not reactivated or erased during subsequent layers in the creative process.

WHAT YOU NEED

- » ACRYLIC PAINT
- » BALLPOINT PEN
- » GEL PEN
- » MIXED-MEDIA PAPER
- » PAINTBRUSH, LARGE ROUND
- » PAINTBRUSH, SMALL FLAT
- » WATER-SOLUBLE PENCIL
- » WATERCOLOR PAINT
- » WAX PENCIL OR CRAYON

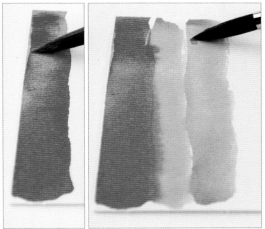

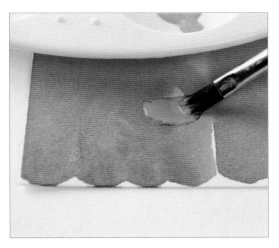

1 Load a large brush with watercolor paint. Use a single motion and move the brush from left to right to add stripes of color to a sheet of mixed-media paper. Reload your brush only when it is depleted of color. Continue adding stripes until your sheet is fully covered. Let it dry.

2 Load a small flat rush with acrylic paint. Place the brush down off center on the paper and push down firmly but gently. Lift the brush up in one fluid motion, letting the brush tip kiss the page. Repeat several times to create a small cluster of marks. Let it dry.

3 Use a ballpoint pen to fashion small Xs. Layer one or two Xs to create a basic asterisk-shaped mark. To keep your marks nice and loose, work quickly. Focus on using an odd number of lines and keeping them confined to a small grouping.

4 Use a wax pencil or crayon to create a series of less-than-perfect lines. Without lifting the pencil, move it from one edge of the paper to the next to create a short stack of irregularly shaped and spaced lines. Focus on the rule of thirds to draw a band of lines that creates interest.

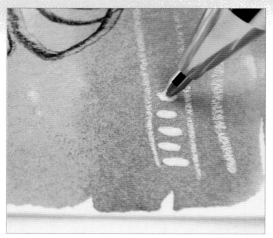

5 Dip a water-soluble pencil into water and, without lifting the pencil from the page, add rings to the paint marks you created in step two. Move the pencil around two or three times in a single quick movement to create nonuniform circles. Let the puddled lead dry.

6 Use a water-soluble gel pen to quickly scribble small knots between the lines you created in step four. Work quickly to help create marks that are unified but not identical. Using a scribbling motion will allow each mark to be different. Reign in the urge to fill them all in completely.

» Make Your Mark: A Tip «

Think of the rule of thirds. Creating marks that are anything but dead center in your artwork will help guide the viewer to other parts of your piece, creating an interesting composition and unique focal point. When it comes to quantity, try adding an odd number of marks as this is always more visually pleasing.

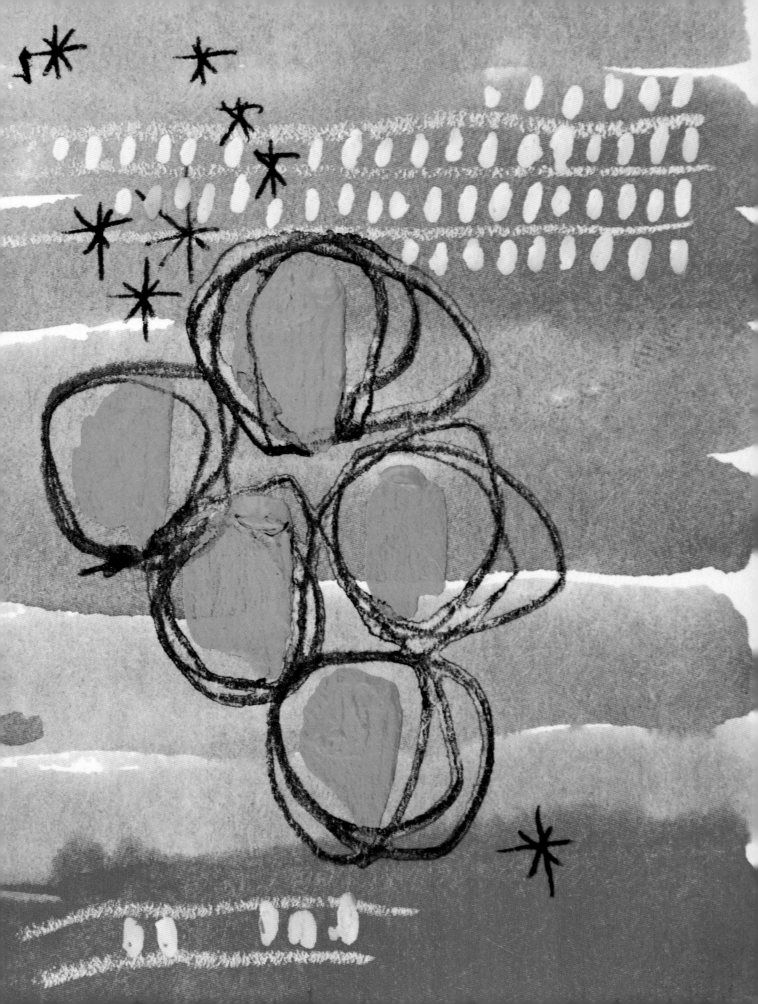

Hands On

CREATING YOUR OWN UNIQUE IMPRINT

Consider your hands for a moment. They are, perhaps, the most basic of all the mark-making tools known to artists. Not only are your hands and fingers unique to you, they are the perfect built-in tool to have at the ready when creating. There is no other tool that can create something so distinctly you as your own hands and fingers. Don't be afraid to get messy and dig into art with these amazing extensions of yourself.

As effective mark-making tools, your fingers and hands allow you the ability to create up close and personal with your work. You have total control of these tools and can manipulate them as only you know how. Grab your journal and begin experimenting with these primitive tools, making notes about how they perform given a wide berth. Don't limit yourself to dipping your fingers into paint. Think outside the box and test your hands in conjunction with a wide variety of mediums. Get familiar with your fingerprint and begin to explore the brains behind what they can do.

WHAT YOU NEED

» ACRYLIC PAINT

» MIXED-MEDIA PAPER OR CANVAS

» PALETTE

1 Dip your finger in paint and, beginning in one corner of the paper, move the paint out and toward the center of your page or canvas. Spread the paint out as you go using your finger as a palette knife. Let it dry.

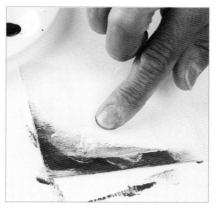

2 Using the same finger, begin blending a small amount of white paint into the existing paint color on your paper or canvas. Let the two paint colors blend together as you move your fingertip across the page, embracing the painterly ridges and valleys created with your fingerpaint. Let it dry.

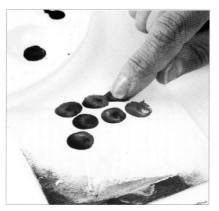

3 Dip your finger into acrylic paint and gently press the tip of your finger down on the paper or canvas. In one motion, lift your fingertip off the page, giving it a little push up as you do to create a peak in the paint. Repeat until you have a small cluster of marks. Let it dry.

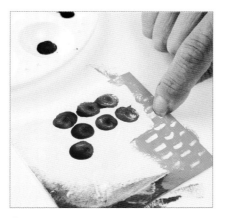

4 Add a final layer of paint to your paper or canvas using your finger as a brush. Concentrate on the rule of thirds, this time confining the paint to the bottom third of your paper or canvas. Quickly, before the paint dries, use the tip of your finger to etch small marks into the paint. Let it dry.

» » Make Your Mark: A Tip « «

Keep a damp cloth handy when working with your hands. Use the cloth to mop up any extra paint or ink from your fingers and/or work surface. Hang it up or lay it flat to dry. Cut it up and use it in your next mixed-media project as a textural mark-making element.

Stamp

CREATING A UNIQUE MARK-MAKING TOOL

Hand-carved stamps are a creative way to add one-of-a-kind marks to your work. As an artist, you will find yourself coming back to the same set of marks over and over again. By carving these into rubber, you can quickly replicate anything from a single bold mark to a large collection of smaller marks with the single press of a stamp.

As you experiment and practice, add sketches of your favorite marks in your journal and use them as a springboard when carving your mark-making stamps. Record your finished images by stamping them in your journal. You are always growing as an artist. As you do, your approach to mark making will morph and change along the way. You will begin to alter and reconstruct your original marks so they better reflect you and your sense of style in artwork. Refer to the stamped images in your journal to create newer hand-carved versions of your marks along the way.

WHAT YOU NEED

» ACRYLIC PAINT
» ACRYLIC PAINT PEN
» INK PAD, PERMANENT
» MARKER, PERMANENT
» METALLIC MARKER
» MIXED-MEDIA PAPER
» SCISSORS, HEAVY DUTY
» STAMP-CARVING SOFT BLOCK
» STAMP-CARVING TOOL

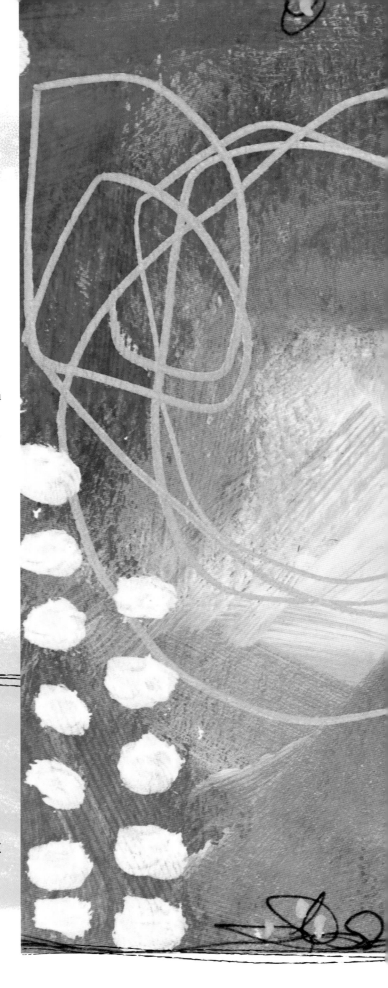

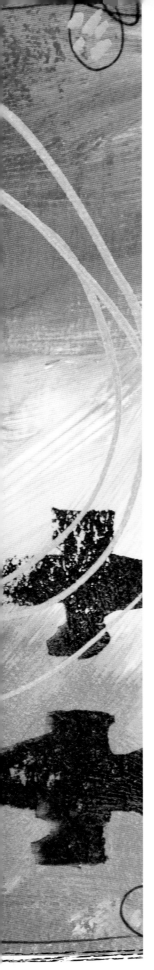

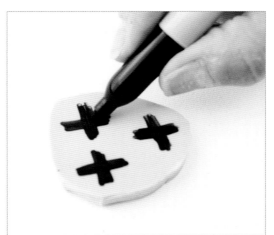

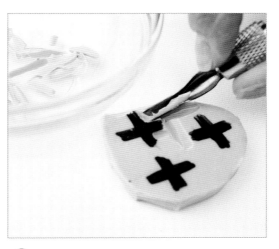

1 Use a permanent marker to sketch a small trio of marks on a piece of stamp-carving rubber. Keep in mind that the more detailed the marks, the more intensive the carving process. You will be carving around your sketched image.

2 Use a stamp-carving tool to remove the rubber outside the edges of your sketched image. Removing the rubber inside your sketched image will create an inverse stamp. Work slowly and carefully, carving nice wells around the image.

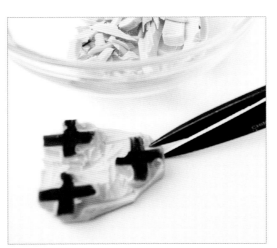

3 Use heavy-duty scissors to clean up the edges and trim any stray rubber away from your newly carved image. Do a test print and repeat the steps above, as needed, to clean up and refine your stamped image.

4 Use your finger to apply paint to a sheet of mixed-media paper. Begin at the corner and work your way toward the center of the page. Repeat with a second and third color, blending the edges of each new color. Let your fingers create ridges in the paint as you go. Let it dry.

5 Press your newly carved stamp onto an ink pad several times to prime and ink it. Press the stamp firmly onto the painted page. For a more interesting look, take your stamped image off the edge of the page. Use permanent ink to allow for layering of subsequent mediums.

6 Finish your stamped image by layering a series of simple marks. Sketch the edges of your page with a permanent marker and fill with color. Create a string of small opaque marks using an acrylic paint pen. Form a simple focal point by scribbling a series of imperfect circles with a metallic marker.

You Got This!

Stamp carving can be an intimidating task. As you create, focus less on the creation of the stamp and more on the marks you are hoping to create. Try fashioning large, bold marks first, as this will help you become more familiar with the tools at hand. Once you are comfortable carving, you can begin to focus on the practice. Practice is key to the art of stamp carving and with it you will gain better insight into what makes a stamp a unique and powerful tool for making marks. Approach carving as you would a blank canvas and experiment. As your stamp begins to take shape, think about negative space, line work and detail marks. Grab an ink pad and create multiple impressions as you carve, allowing you to observe how your marks bloom and grow throughout the process.

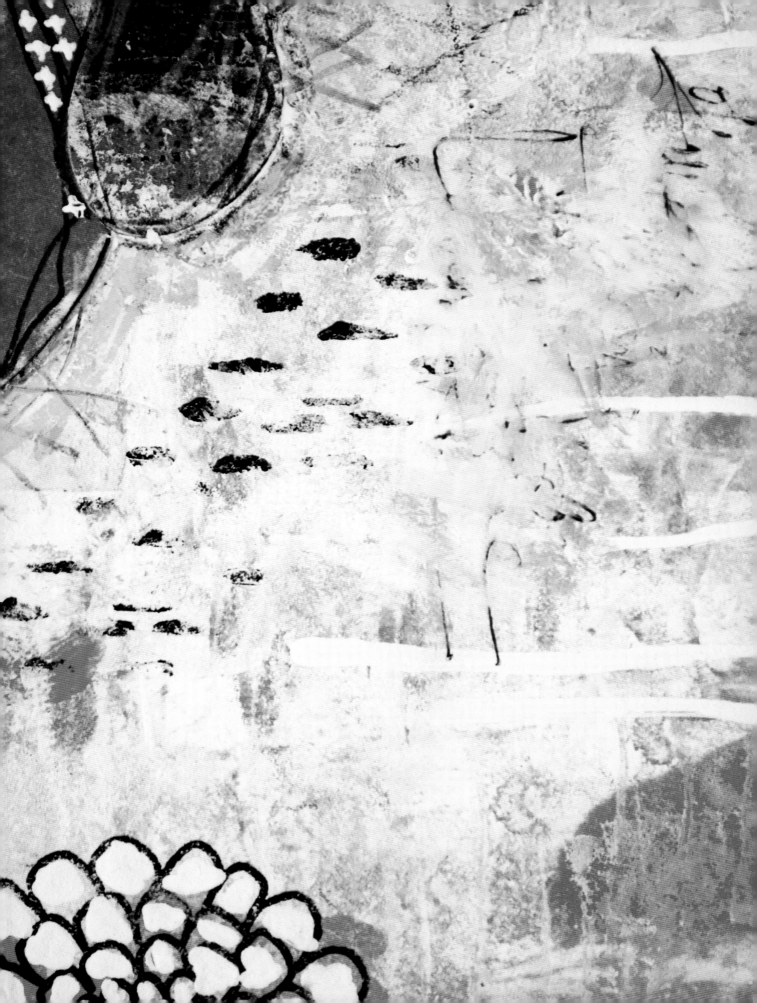

Raspberry Juice

HANDCRAFTED ORGANIC COLOR

As a mark maker, you will rely heavily on colored mediums to bring your marks to life. While there are countless pigment choices available to you, consider doing a study in natural hues using only handcrafted organic ink. Use your journal to record your process and then do a field test using all your favorite mark-making tools. Make notes on which tools work best with your handcrafted ink.

Organic inks and dyes are not the obvious choice for paintings or other mixed-media pieces that will be exposed to harsh light or temperatures, but they can be an interesting option when creating more unique pieces and are a great way to stretch your creative colorist muscles.

Experiment with different flora, berries and vegetables. Typically the colorant you will see when crushing the pulp will vary slightly from the hue once you have added a binding agent such as vinegar or alum. These ingredients help create a colorfast quality in the ink, and while the colors are beautiful, they are not meant to withstand time. Create and use these handcrafted inks more as an investigation into what color is, how it reacts and what you can do to mix-and-match colors to produce a wider range of hues.

WHAT YOU NEED

- » BLACKBERRIES OR RASPBERRIES
- » GLASS BOWL
- » HEAT TOOL
- » MORTAR AND PESTLE OR WOODEN SPOON
- » PAINTBRUSH
- » SEA SALT
- » STRAINER
- » VINEGAR, WHITE
- » WATERCOLOR PAPER

1 Gather your supplies. You will need several fresh raspberries. Blackberries will also work for this experiment. You will also need white vinegar to use as a binding agent. This will create a semicolorfast tint.

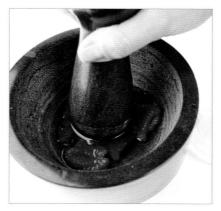

2 Add a handful of raspberries to a mortar. Use a pestle or the back of a wooden spoon to crush the berries into a dense pulp. Add vinegar and continue crushing until the pulp is mostly liquid.

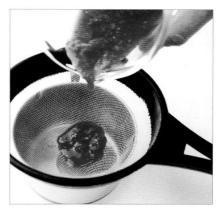

3 Transfer the crushed raspberries to a strainer and rest the strainer over a glass bowl or vessel. Let the mixture rest until all the liquid has strained into the bowl. Remove the strainer and stir well.

4 To test the color of your raspberry pigment, load a paintbrush with the ink and create a pool of color on a sheet of watercolor paper.

5 To alter the color of your raspberry ink, add a pinch of sea salt to the surface pool of color. Let the salted ink rest on the page for several minutes.

6 Use a heat tool to speed up drying time. Make notes in your journal on color changes. Once dry, gently brush the salt crystals away to reveal your pretty organic ink.

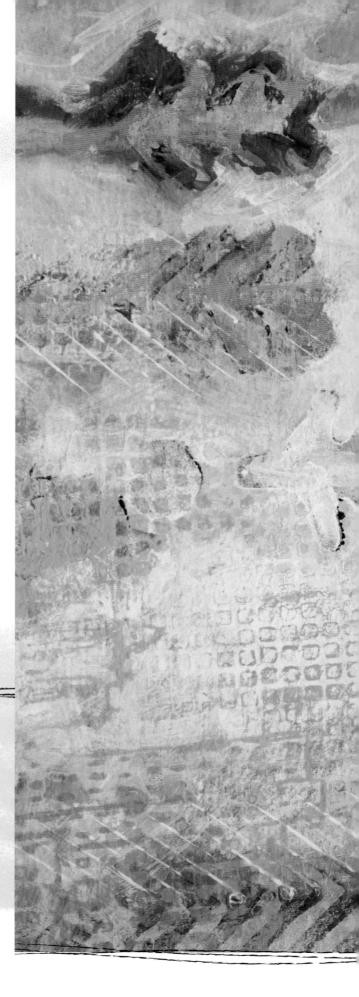

Stencils

STENCILS AS LAYERED MARK-MAKING TOOLS

Stencils are fantastic tools for creating large and small marks quickly. As you work, you will find that many marks that pull a piece together are created with more than a pen or pencil. There are thousands of store-bought stencils available for aiding in making marks simply and quickly. Easily used with a wide variety of mediums, stencils are the quickest way to incorporate a huge assortment of marks into a work of art.

When you are creating a larger work of art, make a note in your journal of the types of marks you hope to see evolve in your piece. Sketching these larger marks ahead of time can help you determine what types of mark-making tools you will need to help bring these marks to life.

Stencils don't have to be limiting in their value as mark-making tools. Study a handful of your favorite stencils and record different ways you can alter the stencil to make it more unique when using it in your work. Think about how you might be able to use just a portion of an existing stencil to make it more interesting. Study your favorite parts of a stencil and sketch them out in your journal. Refer back to these sketches when working to better understand how they help build character in your artwork.

WHAT YOU NEED

- ACRYLIC PAINT
- BRISTOL PAPER
- CHINA MARKERS, BLACK AND WHITE
- COSMETIC SPONGE
- GEL PEN, WHITE
- METALLIC MARKER, GOLD
- PAINTBRUSHES, ASSORTED
- PALETTE KNIFE
- PENCILS, ASSORTED
- PENS, ASSORTED
- SHORT CUTS, WHITE (KRYLON)
- STENCILS, ASSORTED
- WHIPPED SPACKLE (FABER-CASTELL)

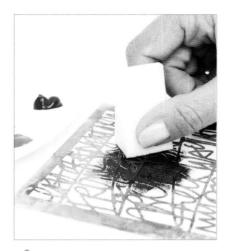 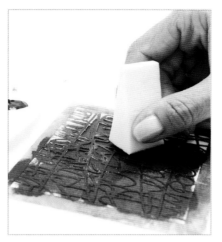 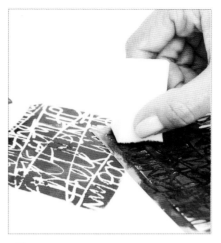

1 Lay your stencil on a sheet of bristol paper. If your stencil slides around easily, secure its edges with a few pieces of removable tape, such as washi tape or artist masking tape.

Load a small sponge or wedge of foam with acrylic paint and pounce any excess paint onto your palette or a scrap of paper a few times before beginning. Dab the paint through your stencil and onto your artwork.

2 Using a clean sponge for each new color, dab two or three complementary colors of paint through your stencil until you have filled the entire image. Before removing the stencil, use a clean sponge to gently blend the edges of each color. Let it dry.

3 Use your fingers or tweezers to gently lift the stencil and reposition it so that it is slightly overlapping the first stenciled image. Repeat steps one through three until you have covered your entire sheet of bristol. Let it dry completely.

»»» Make Your Mark: A Tip «««

Use a clean sponge to blend the edges of complementary paint colors through a stencil to create a multihued background. For added dimension, use texture pastes in conjunction with your stencils. Always wipe stencils clean after using them with heavy-duty pastes and mediums.

Once you have exhausted all of the paint on the sponge tip, use scissors to trim the painted end off the sponge to reveal a fresh layer.

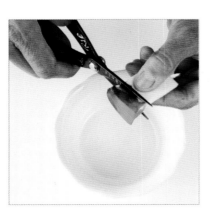

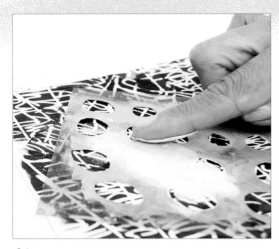

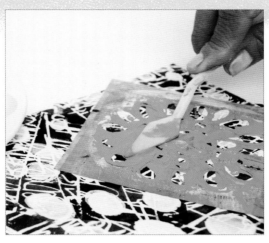

4 Position a second stencil and rotate it slightly so that it's sitting in a different direction than the first stencil. Dip your finger into white paint and gently rub and roll your finger across the stencil, creating soft ridges at each opening's edge. Repeat and let it dry.

5 Position a third stencil onto the dried image. Use a palette knife to move acrylic paint across the surface of the stencil, letting the knife and stencil edges dictate where the paint settles. The paint will be thick, so carefully lift your stencil and let it dry completely.

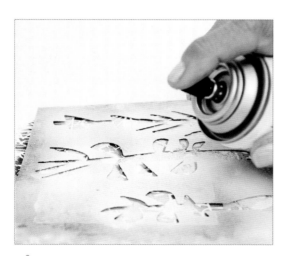

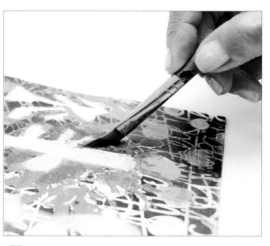

6 Move your work to a well-ventilated area. Position a fourth stencil over the dried image and, once again, rotate it into a new position. Spray paint through the stencil opening. Use short, smooth bursts of paint to create a more prominent focal point.

7 Use a small angled brush to begin adding color over and around the edges of your stenciled marks. Only fill portions of the page, working your way out from the edge of your focal mark until your brush is depleted of paint. Let it dry.

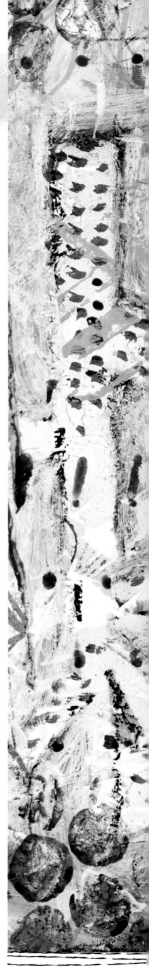

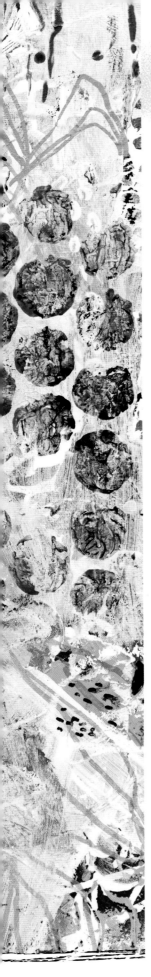

8 Reposition your focal mark stencil over the spray-painted image to mask off the other areas of your work. Using a small round detail brush, add small marks inside the stencil opening. Press the brush down and lift up quickly, letting the brush tip kiss the page as you do.

9 Use a small flat brush to layer in heavily defined line marks around your final stenciled image. Using your original colors (steps two and three) pulls your focal mark forward and adds even more depth and dimension to your page. Let it dry.

10 Position a fifth stencil over the edge of your work and use a clean sponge to add whipped spackle or modeling paste through the opening. This time, use a gentle rubbing motion when adding the texture paste to create slight ridges near the edges of the openings. Let it dry.

11 Add your final marks using a variety of tools, including water-soluble and wax pencils. At this stage you may find yourself adding even more color and stencil marks. Keep layering until you love your piece, allowing plenty of drying time in between each stenciled layer.

Repurposed Tools

MARK MAKERS ARE FOUND EVERYWHERE

You will need to train yourself in the art of re-evaluating things for a new purpose before you discard them. Once this becomes a learned habit, you will be looking at the world around you in a whole new light. Many ordinary items found in your home, such as cardboard tubes, rubber bands, nail polish and drinking straws, are begging to be fashioned into mark-making tools.

With fresh eyes, you will find yourself transforming even the simplest of objects into interesting and unique mark makers. Study the mundane items around you and become familiar with their manipulative properties. Can you snip the edges of a salvaged key card to turn it into a decorative scraper? What sort of marks will bubble wrap or rubber bands create when fashioned into a brayer? What kind of fascinating marks can you create when you fill a dropper full of ink and force it across the page?

As you master the art of upcycling and recycling, you will find yourself reaching for almost everything as a mark maker. Buttons, fruit netting and sea sponges; paper bags, toothbrushes and combs; bottle caps, sticks and small nuts and bolts; nothing will be off limits. Use your journal as a landing place for recording what you find. Play with and alter your repurposed objects and note how you can make adjustments to them, turning them into what are sure to be some of your favorite mark-making tools.

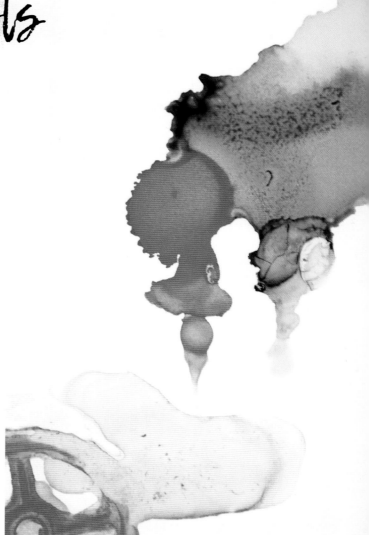

WHAT YOU NEED

- » ACRYLIC INK
- » ACRYLIC PAINT
- » BUBBLE WRAP
- » CARDBOARD TUBES
- » CLOTHESPINS
- » COTTON SWABS
- » DRINKING STRAWS
- » ELASTIC BANDS
- » KEY CARDS
- » MAKEUP WANDS
- » MIXED-MEDIA PAPER
- » MUSLIN FABRIC SCRAPS
- » PAINTBRUSHES
- » SEA SPONGES
- » TAPE, TWO-SIDED
- » TOOTHBRUSHES

BUBBLE WRAP AND RUBBER BANDS

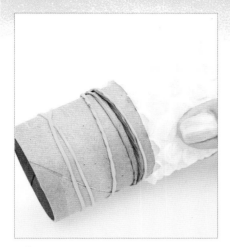

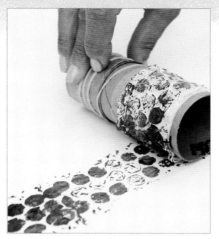

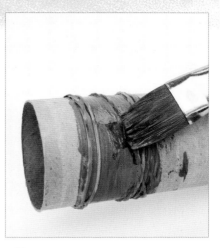

1 Wrap one half of a cardboard tube with elastic bands in assorted sizes.

Use two-sided tape to adhere a piece of bubble wrap to the other side of the tube. You may choose to wrap an entire tube in either elastic bands or bubble wrap, resulting in a wider finished application of each type of print.

2 Add paint to the bubble wrap on your cardboard tube. You can simply brush the paint on for a thinner, more precise impression when rolled, or you can roll the wrapped tube directly into the paint, which will result in a thicker, less defined print. Roll the loaded wrap over paper to make the print.

Remove the wrap or let it dry before using again to avoid mixing the colors.

3 Use a heavily loaded brush to paint all of the elastic bands on the cardboard tube. The cardboard will want to soak up some of the wet paint, so a heavier application will result in a more defined print of the bands when rolled. Keeping the bands near one end of the tube will make it easier to roll once the paint is applied.

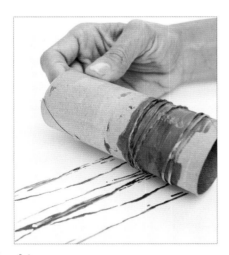

4 Roll the loaded cardboard tube across your substrate in a quick, fluid motion. Repeat the motion until all of the bands have been exhausted of color. Crisscross the marks as you roll to get interesting and painterly lines. The bands will leave a slight ridge along the edges of the color, adding even more dimension to the marks as they dry.

You Got This!

Consider your tool collecting adventure a creative exploration. The more inventive your thinking as you gather your tools, the more interesting your future marks may be. Look at objects not for their intended purpose, but for what they may be able to do for you as a mark maker. As you begin to compile your tool kit, try to pick up a variety of recycled elements. Having mark makers in a wide assortment of sizes and shapes will help make creating layers of marks even more interesting. Most importantly, choose recycled tools that speak to you; in doing so, you will broaden your own unique set of marks along the way.

CARDBOARD TUBES

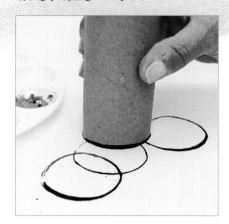

DRINKING STRAWS

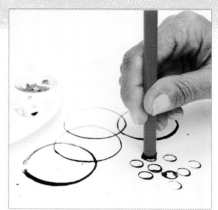

KEY CARDS

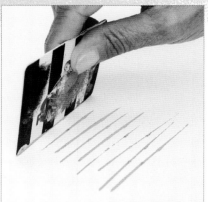

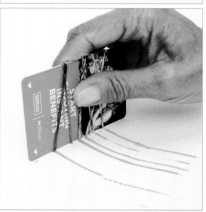

You can cut, fold and reshape cardboard tubes into a huge assortment of mark making shapes; however, the natural circular form makes a great mark for larger projects. You can reuse these as they dry or cut them down and start fresh with a new color. Just dip in paint and press gently but firmly onto your substrate.

Similar to their larger counterparts, drinking straws can be cut and shaped like the cardboard tubes. These are great mark makers and leave a less than perfect imprint when heavily loaded with paint. For larger projects, consider using an elastic band to secure several straws together to create one large multipoint tool.

Heavy-duty plastic cards are a great repurposed tool. Dipped in paint, the edge of the card can be used to make painterly lines. Rocking the card back and forth as you apply the paint to your substrate will create small valleys in the paint that, when dry, result in interesting texture. This same method also works well with texture pastes.

Key cards are easily altered to create an even larger array of marks. Try wrapping the card with elastic bands in varying sizes. Dip the banded card into paint and pull it across your substrate, rocking the card away from you as you pull. You can also snip small pieces off of the card's edge using heavy-duty scissors, to create interesting and decorative scrapers.

»» Make Your Mark: A Tip ««

A great way to collect repurposed tools is to go on a field trip. Secondhand stores are a great starting point. Begin the search for anything that can be collected and used as a tool for making imprints. Take your journal along on these trips and try this fun exercise—pick things up and pretend to make marks with them in your journal. How does it feel when you hold it in your hand? Will it work with paint and ink? Is it washable? Can you reuse it? Will it fit in your toolbox? Is it budget friendly? If you answer yes to any of these questions, it might be worth taking home with you. Once you have collected a few things, give them a real test in your journal by using them with a wide variety of mediums. Make notes about how they work for you.

MAKEUP WANDS

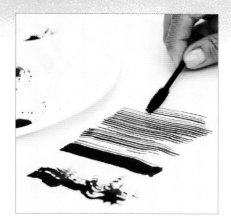

Makeup wands are a great tool for creating lots of small line marks quickly. They are designed to be heavily loaded with mascara and work wonderfully with paint and ink. Dip the wand in acrylic ink and brush along your substrate. The first stroke line will be much heavier followed by thinner, more defined lines. Paint will give an even heavier, less defined impression.

COTTON SWABS

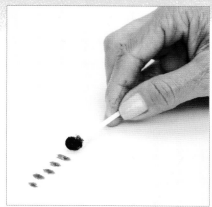

Easy to find and budget friendly, cotton swabs make great mark makers and are handy in a pinch as a detail brush. The absorbent quality of these tools make them great for ink and paint, allowing a longer open time with the medium as you work. Many of these tools are double ended, giving you the added bonus of working with two colors at once.

SEA SPONGES

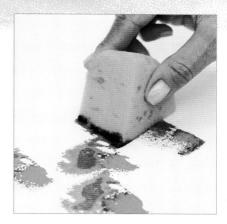

Dense sponges are perfect for making lots of interesting marks in your artwork. All-natural sponges will have a rougher, more irregular surface texture while the manufactured versions will have a smoother, more consistent exterior. Both are easily cut into smaller shapes. Use dry with paint or ink for defined prints or dampen before adding medium for more fluid marks.

CLOTHESPINS

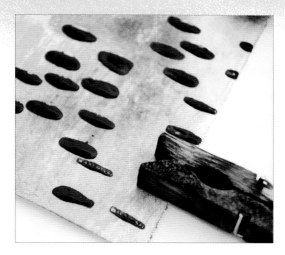

Use a recycled clothespin to create a series of nearly identical marks. Dip either of the two wooden ends into paint or ink, and press firmly onto your substrate. You will be able to make a large number of marks quickly given that every imprint will form two marks.

Second-Life Paint

LOOK AT THE WORLD AROUND YOU

In looking around, you will discover that there are many extraordinary marks to be found: chinks in a sidewalk or a rusty patina on a metal chair, for instance. The world is made up of an ongoing series of beautiful and interesting marks. Now get out your journal and take an even closer look. Narrow your search to your creative space and scrutinize the tiny bits and pieces of your work that would normally be cast off. The inky remnants of a cloth or the cut edges of a collage sheet are easily tossed aside and yet both are worthy of a second glance. One of my favorite things to reclaim in the studio are paint skins. Easily pulled and functional as freeform marks, these bits will add an element of texture and dimension to any piece of artwork. Note the two sides of a pulled paint skin; both are equally beautiful. The underside will present a glossier, swirled effect as a result of the subsequent paint layers; the topside will appear more defined, much like the original paint pools as they were added to the palette.

WHAT YOU NEED

» ACRYLIC PAINT

» BRISTOL PAPER

» GEL MEDIUM

» LEATHER NEEDLE

» PAINTBRUSH

» PLASTIC PAINT PALETTE

» SCISSORS

» SEWING MACHINE

» THREAD

» TWEEZERS

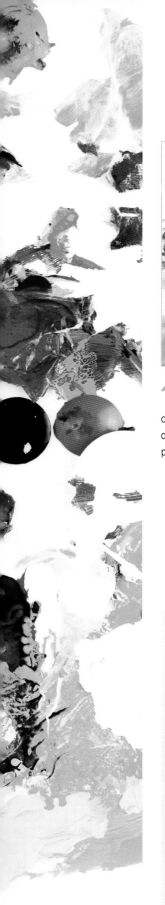

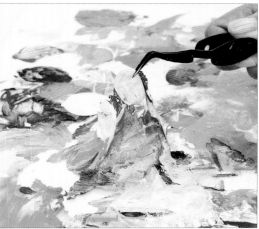

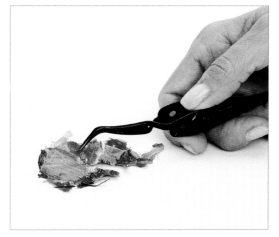

1 Use fine-tipped tweezers to carefully pick up a piece of paint. Begin with a thicker dried chip so that you can have a secure grip on the dried medium. Work slowly and gently, pulling the tweezers away from you as you peel the paint up and away from the palette.

2 Use your tweezers to pull apart small, workable pieces of paint. Alternatively, you can use scissors to cut your freshly harvested paint chips into desired shapes and sizes. Once you have chosen your pieces, use the tweezers to place them chosen-side up onto a piece of bristol paper.

»»» Make Your Mark: A Tip «««

Reserve a small plastic paint palette for heavy body paints and mediums. These will create the best paint skins or chips. The more you use your palette, the more interesting your layers will be when you gather your paint chips. Let your palette dry completely before trying to harvest any chips. Once collected, your paint skins are best stored in an airtight container between small slips of deli or wax paper.

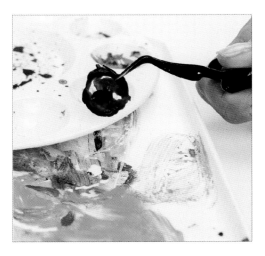

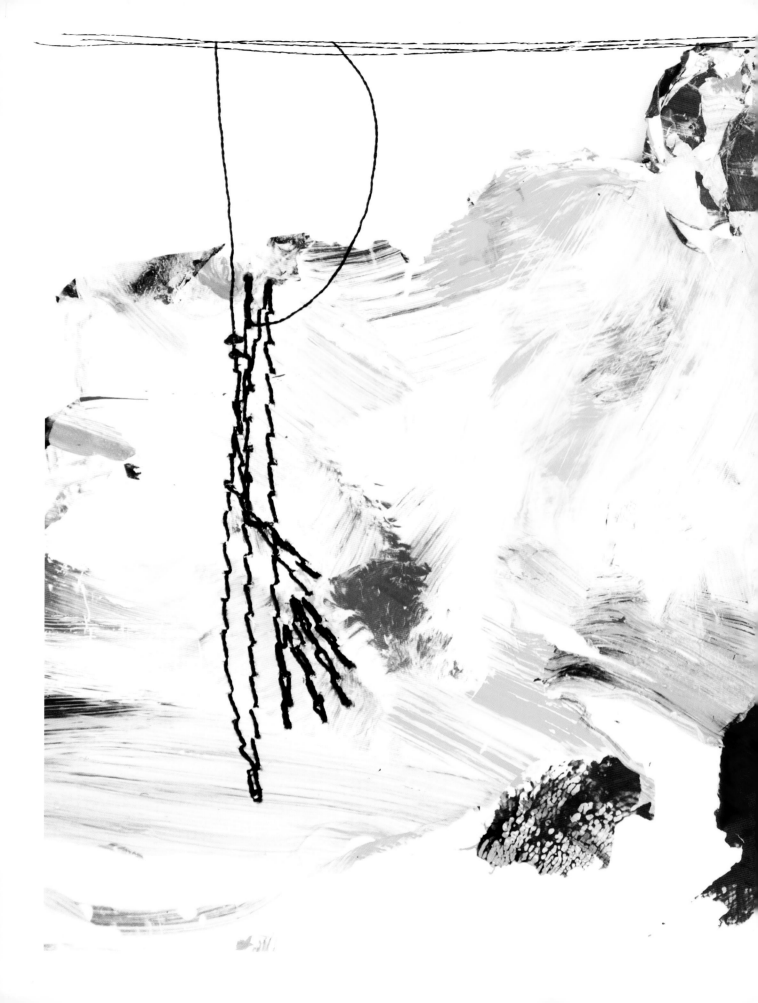

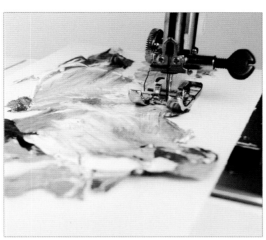

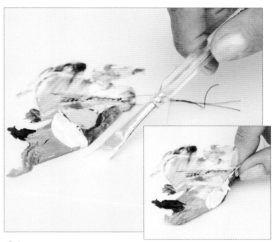

3 Carefully place your bristol sheet layered with the paint chip under the foot of your sewing machine. Using a leather needle, create several back and forth stitch lines across the center of your paint chip. Trim the threads, remove the paper and wipe your needle clean of debris.

4 Gently peel back any unstitched portions of the paint chip and add a layer of gel medium to the surface below. Move the paint chip back and gently pat into place. Repeat on other areas of your paint chip and seal the edges with gel medium, as needed. Let it dry completely.

You Got This!

As you look into incorporating the remnants of paint into your creative work, think about chance. Oftentimes, things left to chance can be the most visually pleasing. Experiment with both planned paint layers and those that are created more organically as the result of other art explorations. As a mark maker, you are always on the hunt for unusual and compelling marks that will add a new level of interest to your work. As you delve into the possibilities of what your tools can do for you, don't stop at paint. Look beyond the obvious and investigate the properties of other mediums both as they stand alone and when they are mixed and layered together. Consider dedicating an art palette to these small studies, then document and collect your finds in your journal.

Organic Tools

CREATING MARKS WITH NATURE

There is something very striking about the beautiful one-of-a-kind marks made with organic tools. These shapes cannot often be replicated to the degree that we may discover them in nature. That is why they are a great companion tool for monoprinting.

Most organic mark makers serve us best one or two times at most, with the exception of things like twigs, feathers and stones. Flora, leaves and stems, as well as most fruits and vegetables, leave stunning prints in their wake but must be used while fresh to produce the cleanest and most detailed impressions. Using these mark makers with a printing plate or similar tool will allow you to get several good impressions out of a single organic mark maker.

Just because these tools have a short life span does not mean you cannot get creative with them. Record your examinations of these tools in your journal. Make notes on the marks they leave when used just plucked from the stem, then cut, peel and bend them into new shapes and record those marks as well. Use several combinations of these organic mark makers and add lists of your favorites to refer back to when you are creating.

WHAT YOU NEED

» ACRYLIC PAINT

» BRAYER

» BRISTOL PAPER

» COSMETIC SPONGES

» HEAD OF CELERY

» KNIFE

» LEAVES, ASSORTED

» ONION, SMALL

» PALETTE

» PAPER TOWELS

» PRINTING PLATE

» TWIGS

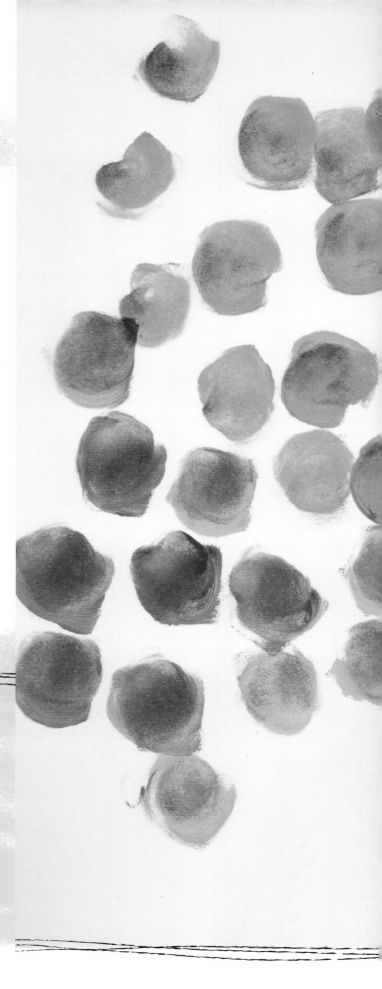

VEGETABLES

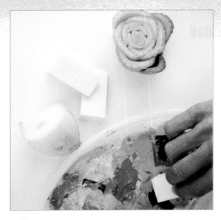

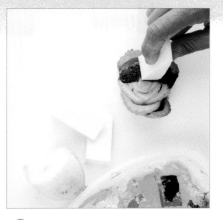

1 Use a knife to cut the bottom three inches off of a fresh head of celery and set it aside. Cut a small onion in half. Use a paper towel to pat dry the cut ends of the vegetables. Tap a cosmetic sponge in acrylic paint.

2 Dab most of the paint off onto your palette, then dab the painted end of the sponge onto the cut end of the celery head.

3 Move the paint across the cut end of the celery, adding a second color as you go for an interesting color effect when you stamp the image. Repeat for the onion.

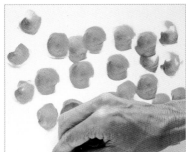

4 Flip the vegetables over and, one at a time, press the painted side onto the bristol paper using firm, even pressure for the cleanest print. Re-ink and repeat.

»» Make Your Mark: A Tip ««

Recycle your paint sponges and make marks along the way. Push the sponges down onto the page and twist them slightly to create a colorful mark. Repeat several times until the paint is depleted from the sponge.

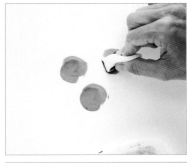

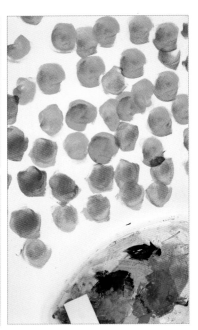

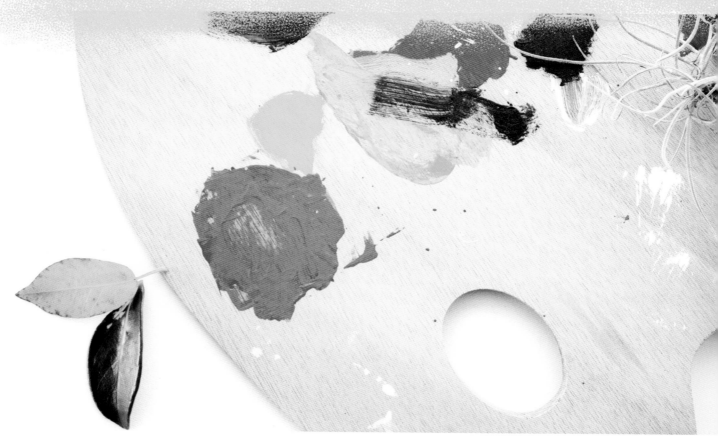

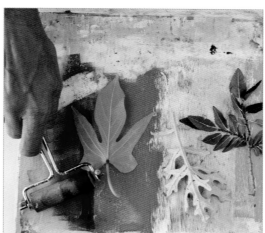

1 Add several dollops of paint to your printing plate and roll with a brayer to create bold stripes. Overlap the paint with assorted leaves and twigs.

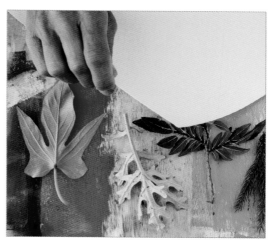

2 Carefully place a large sheet of bristol paper over the entire printing plate.

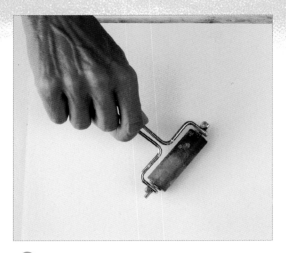

3 Use your brayer to gently but firmly roll over the entire surface of the paper covering your printing plate.

4 Pull the print up and set it aside. Lay a second sheet of paper over the printing plate and pull a second print. This is often referred to as a ghost print.

You Got This!

Don't let a suggestion limit your creativity. Try things and then let your own imagination and resourcefulness take over during the creative process. Imagine that each new technique you explore is an artistic pool, and let the suggested methodology be the diving board. When you take an artistic leap, great things happen. Really exercise your artistic brain when it comes to learning new techniques and exploring new tools. Whether you dive in head first or paddle slowly through new and uncharted waters, learn to let go of the rules and trust your own talent, style and ideology when it comes to making your mark.

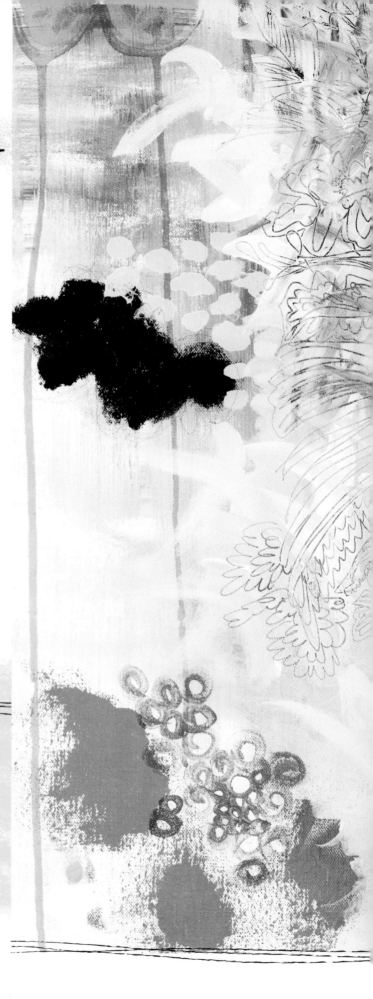

Freeform Marks

CREATING WITH YOUR NONDOMINANT HAND

The real beauty of mark making is that, unlike other art techniques, your marks will become less perfect in nature the longer you continue to make them. This is what you hope to see in your marks. When you look at an image of your marks, rather than seeing a row of perfect circles, you hope to see rings that dance across the page, a reflection of your quick movements and quirky grip. Similarly, the scribbly likeness of an image can be just as visually pleasing as one that is perfectly rendered.

A great trick for becoming more fluid in your mark making is to experiment with your nondominant hand. This can seem like a clumsy task at first but with a little time and practice you will become more familiar with the feel of this new application.

Make sure you grab your journal when you do this workout. You will want to make notes on things such as: which tools feel the most comfortable in your nondominant hand: a long paint brush, a thick barreled pen or a short stick of chalk? Does altering your grip change the amount of control you have with this unfamiliar hand? Which is more difficult: sketching a large image or penning a cluster of small marks?

WHAT YOU NEED

- » ACRYLIC INK
- » BALLPOINT PEN
- » MIXED-MEDIA PAPER
- » PAINTBRUSHES, ROUND
- » WATER
- » WATER BRUSH
- » WATER-SOLUBLE CHALK
- » WATERCOLOR PAINT

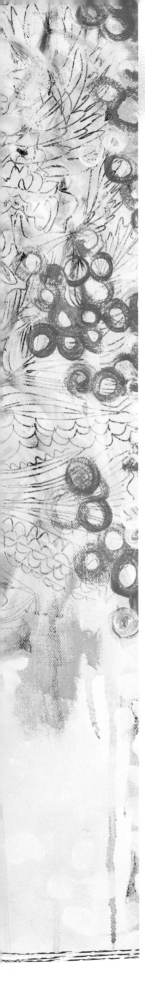

NONDOMINANT HAND

1 Use your nondominant hand to pick up a pen and begin a simple sketch on mixed-media paper. Try to move at a normal pace, moving the pen out and away from you as you work.

2 As you explore working with your nondominant hand for the first time, you will find it is easier to pick the pen up at intervals to readjust your grip. Embrace the interesting line work.

3 This time, try creating a similar sketch using a short piece of water-soluble chalk. The shorter grip can often make the task a simpler one. Work in quick, fluid movements this time.

4 Load a round brush with water. Move the wet brush over the chalk lines. Repeat these steps several times to train your hand to work with both grip lengths.

5 Now use a round-tipped brush saturated with watercolor paint. Again, try to create a similar image only, this time, do not pick the brush up as you move it across the page.

6 Lastly, use a water brush loaded with acrylic ink to scribble a series of marks on the page. Try to work quickly, moving across the page left to right and away from your body as you go.

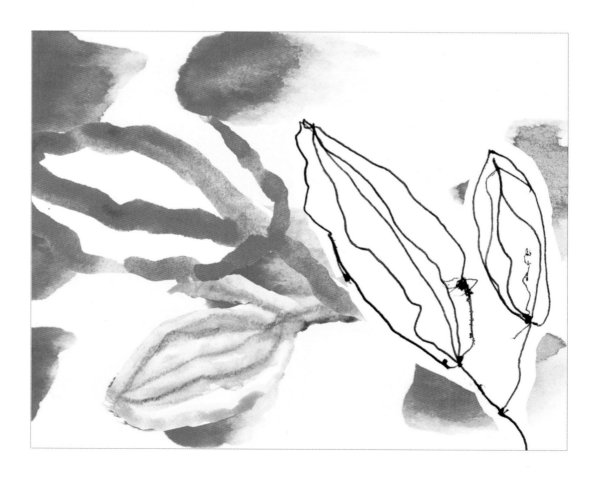

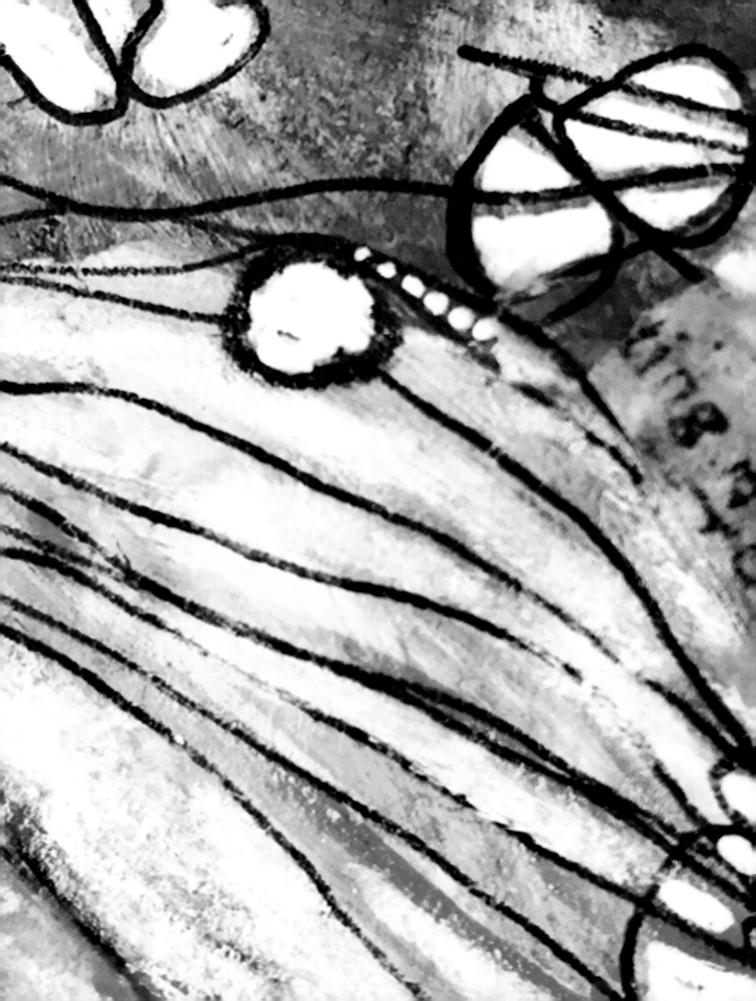

Resists & Negative Spaces

CREATING BLINDLY USING RESISTS

Mark making is so rewarding when the magic of the tools takes over. The biggest hurdle for most mark makers is learning not to overthink the process. Practice and experimentation are key to getting over this obstacle. Over time you will find yourself becoming more daring with your marks, bringing them to the forefront of your work rather than using them as a backdrop for more prominent focal points.

Using resist tools as mark makers is like walking through a familiar museum blindfolded. You know what comes next, what beauty there is to behold and yet you can't quite see it clearly.

Do some tests with different resist tools to get familiar with the concept of working blind. Make notes about which resist mediums are your favorites. Do you like the definition and control you have when sketching with a colorless wax crayon, or do you prefer the fluid, pooling marks you can create with a wet masking fluid? Practice with resist markers and record their softer, subtler effects. Do a test run using rubber cement. Try splattering it across the surface of your substrate for more abstract marks. Once you are comfortable with the different mediums, try combining several together and record the different negative space marks they create in your artwork.

WHAT YOU NEED

- » ARTIST MASKING FLUID
- » ACRYLIC PAINT
- » MIXED-MEDIA PAPER
- » PAINTBRUSHES: ANGLED, FLAT AND ROUND
- » WATER-SOLUBLE INK
- » WATERCOLOR PAINT

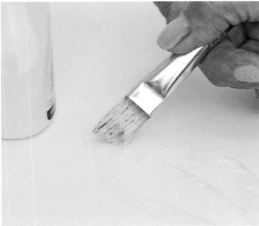

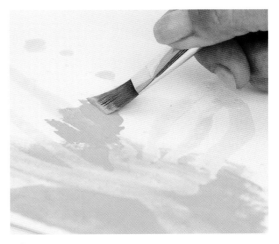

1 Dip a flat brush into artist masking fluid until it is heavily loaded with the solution. Tap the brush off and draw a simple image on mixed-media paper. Add a few drips to the page. Let it dry completely. The fluid will take on a darker hue as it dries and will become springy to the touch.

2 Once the masking fluid is completely dry, use an angled brush to paint over the sketch with acrylic paint. Use the tip of the brush to get in very close to the edges of the masking fluid and around all the drips. Let the paint dry.

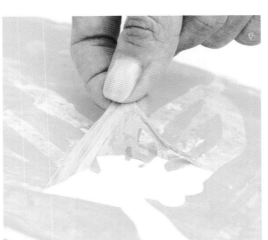

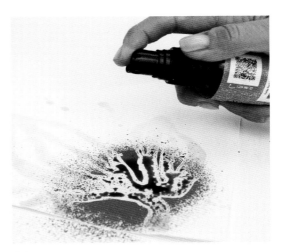

3 Once the paint is dry, carefully begin to remove the masking fluid. To begin, gently rub near an edge of the fluid, rolling it back slightly until you can pull it off the surface of the page. Work slowly, continuing to rub and roll the fluid as you go to release the edges.

4 Repeat step one on a second sheet of mixed-media paper and let the image dry completely. Once dry, spray the entire surface with a water-soluble ink. Let the ink pool and dry where it lands. Once dry, remove the masking fluid by rubbing and rolling it away from the page.

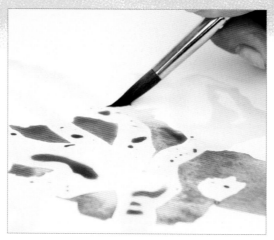
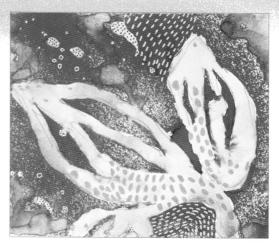

5 Repeat step one on a third sheet of mixed-media paper and let the image dry completely. Once dry, paint over the image with watercolor paint using a round brush. The paint will roll off of the fluid and pool near the edges. Let it dry completely before removing the masking fluid.

6 Now experiment with your negative space marks. Fill them in with smaller marks of a complementary color. Get creative and add white marks around the edges to give the illusion of more negative space.

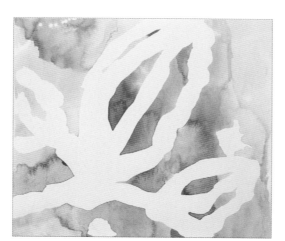

You Got This!

Throughout the experimental mark-making process, be sure to have your journal at the ready. The most important job this record keeper can do is to remind you of what works for you. You will begin to see a pattern the longer you observe your trials. You will find your mediums of choice as well as the marks that are beginning to define you as a mark maker.

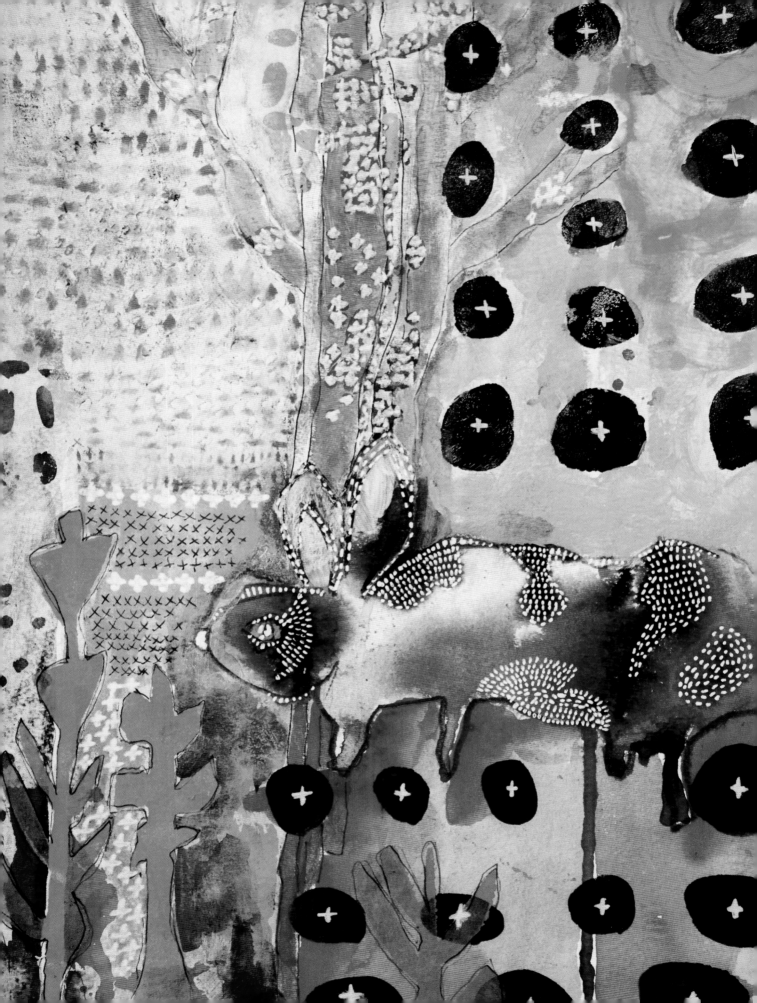

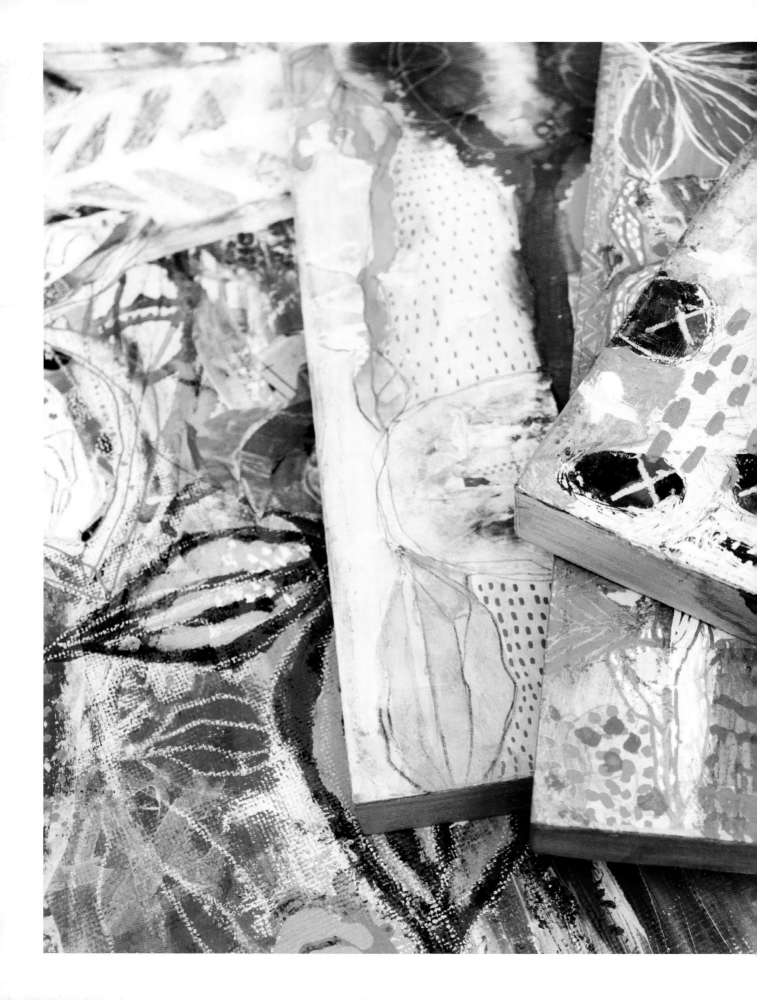

3

The Art

A HOME FOR YOUR MARKS

Creating a home for your marks is an artistic challenge. Exploring and discovering which tools and marks feel comfortable in your hands and work for you as an artist are only part of the creative journey. Your art is what will truly define you as a mark maker. How you interpret marks, and how your marks represent your distinctive approach to art, will be paramount to making art you love—art that reflects who you are as a mark maker. And art is practiced. Over and over again it is made and remade until, finally, it is a finished piece. Fully realized art is just more practiced art, art that has been built upon, subtracted from and reinvented over and over again. Layered and revisited, covered up and started over, art has the power to become something very bold when it evolves from practice.

Collage

HOW TO GET A LOT OF COLOR DOWN QUICKLY

Collage work is one of the more intriguing ways to get a lot of color down quickly. With so many patterns, shapes and materials available, your collage work can just as easily be worked into something structured and defined as it can be free flowing and random. Learning to work your abstract composition into something that reflects your unique creativity will be a lesson in fashioning marks out of a single-planed object. Indistinct and minuscule or oversized and eye-catching collage marks add a recognizable amount of character to any work of art. Selecting planar objects for collaging is an exciting and visionary process. Papers of all varieties and textures that are filled with bold solids, busy patterns and text are all ready to be transformed into something surprising and unpredictable.

WHAT YOU NEED

- » ACRYLIC GLAZING MEDIUM
- » ACRYLIC INKS
- » ACRYLIC PAINTS
- » BALLPOINT PEN
- » BRAYER
- » BRISTOL PAPER
- » DELI PAPER
- » DROPPER
- » GEL MEDIUM
- » GLUE STICK
- » MAGAZINE PAPERS
- » PAINTBRUSH
- » PRINTING PLATE
- » SCISSORS
- » SCRAPER
- » WATER
- » WATER-SOLUBLE PENCIL

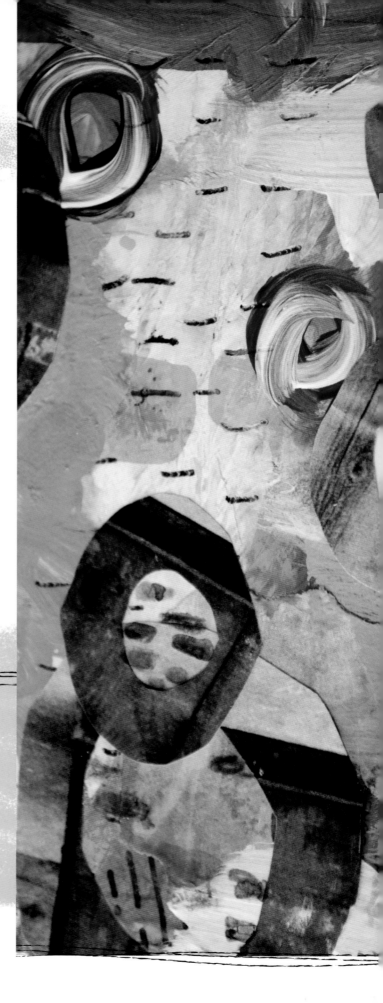

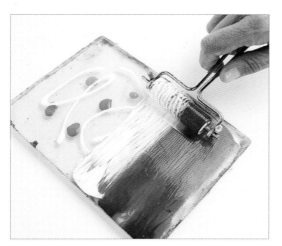

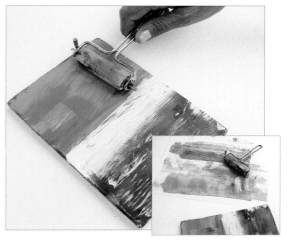

1 Add three complementary colors of paint to your print-ing plate. Adding the paint in small dollops allows for better mixing on the plate. Next, drizzle a small amount of white paint and acrylic glazing medium onto the plate and begin moving the paint around with the brayer.

2 Continue to move the paint into bold stripes with the brayer. Use a light touch when braying to create peaks in your paint. Clean your brayer on a large scrap of paper to avoid mixing contrasting colors. Set this scrap aside to dry and use as collage paper in your future projects.

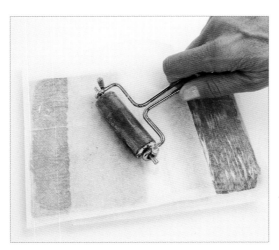

3 Carefully lay a sheet of deli paper on the printing plate and bray over the entire surface of the paper. Gently pull the sheet off of the plate and lay it flat to dry. Repeat with a second sheet of paper to pull a ghost print and remove any remaining paint from the plate.

4 The glazing medium opens up the dry time on the acrylic paint, so be sure to let your prints dry com-pletely before moving on. Trim any excess or unpainted edges away with your scissors. If desired, you can trim your deli paper into assorted shapes for collaging.

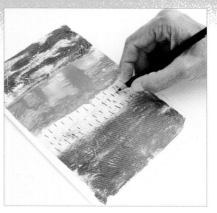

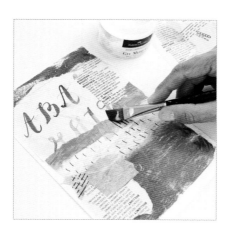

5 Using a paintbrush, begin to add a generous coat of gel medium to a 5" × 7" (13cm × 18cm) sheet of bristol paper. Work from the center of the page, keeping the coat even as you go. Alternatively, you can use a glue stick for this step as it also works well with the deli paper, which you will use in step six.

6 Working quickly to avoid the gel medium drying, lay your deli paper onto the sheet of bristol paper. Use a repurposed key card to smooth all of the air pockets out of the deli paper. Begin at the center of the page and work your way out toward the edges.

7 Once your deli paper is adhered to the bristol sheet and the gel medium has dried completely, add a layer of marks using a ballpoint pen. These marks will be mostly hidden, but they add an interesting underlayer for your collage papers.

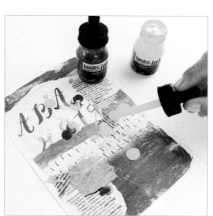

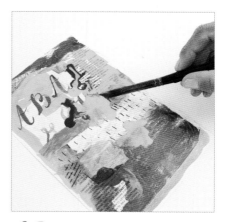

8 Add small bits and pieces of collage paper to your deli paper image. Use gel medium or a glue stick to adhere the pieces to your substrate. To create interesting edges on your collage papers, try tearing them into small scraps rather than cutting them.

9 Add more color to your collage work with acrylic inks. Use a dropper to drip the inks onto the page. Try using two complementary colors and let them pool together. Note how the colors will be absorbed differently by the torn edges of the collage papers.

10 Use a paintbrush to move the ink around and over your collage papers. Don't avoid the painted deli paper but, instead, layer the colors and see what happens. Really begin to build up your color here. Once you are happy, let it dry completely before moving on.

11 Once the ink is dry, pull out your paint palette and add lots of color. Your marks can begin to emerge here in the form of large, loose circles and painterly lines. Use a heavily loaded brush and short, brisk strokes to create lots of texture. Let it dry.

12 Once dry, lay your painted paper near a stack of magazine pages. Choose one or two pages that complement your piece in color and design. Look for areas of the pages that can be cut into smaller, detailed and interesting collage pieces.

13 Begin to alter your magazine pages or collage paper into basic shapes. Remember we are trying to lay a basic foundation here. Large, irregular circles or half circles are a great choice and easy to cut free hand. Avoid the temptation to trace your shape and, instead, practice freehand cutting.

» » Make Your Mark: A Tip « «

Deli paper is a wonderful choice when it comes to creating art papers for all of your mixed-media projects. This thin, almost translucent paper has a dry, waxy coating that makes it moisture proof and, when painted, creates a beautiful and interesting finish. Deli paper is famous among mixed-media artists for its amazing ability to blend seamlessly with a background, making it a favorite choice for collage. Once painted and dry, both sides of deli paper show the color visibly; the painted side is slightly more vibrant while the opposite side is a matte version of the first.

Experiment with deli paper, with and without the printing plate. How many prints could you pull from a printing plate with a single application of paint? Do you prefer the full print image or the ghost print? Did you manipulate the paint before pulling the prints? How well did the deli paper blend in when collaged onto a background? Make notes in your journal for the next time you create with this interesting paper.

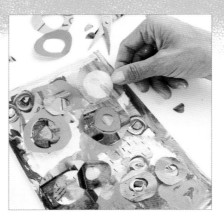
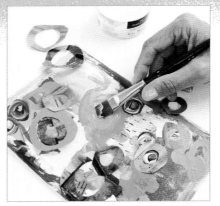

14 Now gently bend your circle shape in half slightly and cut a smaller circle shape out of the center, creating a large ring. Continue bending and cutting your shapes until you have a large assortment of shapes and sizes, both circular and ringed.

15 Play around with your shapes, placing them on your substrate and moving them around until you find a configuration that feels right to you. Remember to work in odd numbers and to stack and layer your shapes to create visually pleasing marks.

16 Once you are happy with your layout, begin to adhere the shapes to your page using a gel medium. To create a smooth surface with the collage pieces, add gel medium to both the substrate and the cut shapes before placing them. Use a scraper or key card to smooth out all of the air bubbles.

You Got This!

Mark making is an ongoing process. Even when you are deeply rooted in a piece of artwork, as a mark maker you are constantly adding and subtracting marks from your piece. These stepped out exercises in creating layers with marks are not fully intended to be finished pieces of art, but instead, a foundation for when you revisit the piece.

Make a point to train yourself to look at your works with fresh eyes. This can mean stepping away for a few hours, a few days or even a few months. That is the beauty of art—you always have the opportunity to shape it into something else. Once you revisit a piece, you will observe things you didn't notice before, for instance, the way a focal point is floating on the surface instead of blending in with the layers surrounding it, or how a series of marks seems too centered. The biggest challenge you will encounter as a mark maker is learning to cover things up. Learning to walk away is the first step. Stop what you are doing. Even if you love what you have created, especially if you love what you have created, take a step back and process what you have done. Then walk away. Next, wait. Wait for as long as feels right and then come back and look at the piece again. Most of the time you will feel inspired and know just what your artwork needs to feel complete.

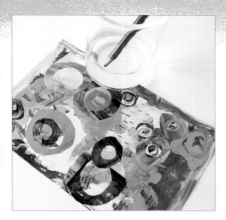

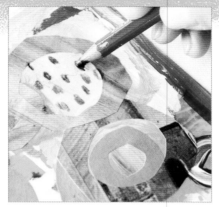

17 Next, take your water-soluble pencil and briefly soak the tip in clean water. Keep the water nearby to re-wet the tip of your pencil as you work. Wetting the tip before working will create very loose, fluid marks. You may also use the pencil dry to achieve more defined marks.

18 Use a loose scribbling motion to form a series of repetitive marks in the center of one or two of your larger collaged pieces. Let the graphite and water pool on the page for the most interesting marks. Alternatively you can use a cloth or towel to pull up the water and create negative spaces.

»»» Make Your Mark: A Tip «««

Create beautiful fabric scraps just by cleaning your brush. First, fold a large square of white muslin or cotton cloth in half and then in half again, creating a smaller square. When you are ready to clean the paint or ink off of your paintbrush, simply dip it into clean water once or twice. Do not scrub the brush on the bottom of the jar. Carefully blot your brush onto the fabric two or three times. Repeat each time you clean your brush. The water on the brush will help the colors pool and blend as you go. Let the cloth dry completely before flipping the fabric square and moving to another section of your cloth. Change your water often to avoid muddy results.

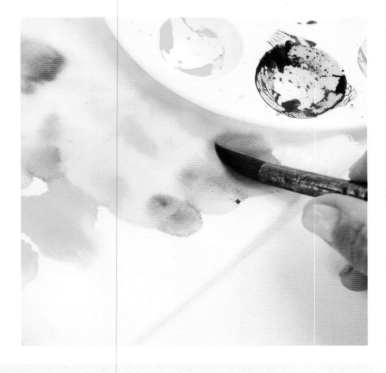

One-Brush Painting

FALL IN LOVE WITH MESSY LAYERS

Falling in love with messy layers is simple when you are ready to let go of the rules and embrace the unexpected. Sometimes we tackle art with the preconceived notion that, in the end, we are creating a finished work. This idea can be intimidating for an artist, especially as a mark maker. By devoting yourself to the experimentation in art, you will find yourself focusing less on the end result and more on the concept of creation. Painting with one brush is a carefree way to explore color, marks and layering techniques as you create. Building a foundation of color this way will catapult that same creativity to the next level, allowing you to make works of art that are uniquely you. As you create and build on your works, remind yourself of the power of layering and work toward learning to create and incorporate beautiful layers of color into your artwork using just a single brush.

WHAT YOU NEED

- » ACRYLIC PAINTS
- » BRISTOL PAPER
- » CARD STOCK
- » CHINA MARKER, BLACK
- » CHIP BRUSH, 1" (25MM)
- » CLOTH OR PAPER TOWEL
- » COLLAGE PAPERS
- » GEL PEN, WHITE
- » GLUE STICK
- » MIXED-MEDIA PAPER, SMALL SCRAP
- » NAIL FILE
- » OIL PASTELS
- » PAINTBRUSH, 1" (25MM) ANGLED
- » PENCIL
- » SCISSORS

1 Load your palette with two or three complementary colors of acrylic paint. Choose a large angled brush and load the dry brush with your first color. Begin in one corner of your substrate and move the paint around and in toward the center of the page.

2 Do not clean your brush or load it with water. Using the same brush pick up a second color of paint and begin adding the paint near the first color, dry brushing and blending the two colors together as you work. Continue working the paint out toward the center of the page.

3 Once again, do not clean or wet your paintbrush before loading it with a third color from your palette. Work this new color into the existing two, filling in more of the page as you go. Let the dry brush leave rough marks on your substrate as you overlap the colors. Let it dry.

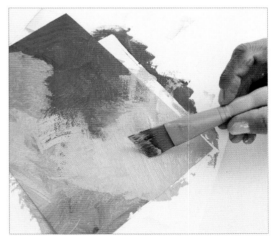

4 This time use a clean, dry brush and load it with a new paint color. Contrasting is okay now that your previously applied paint is dry. Work this final color in from the remaining corner of your page and toward the center, slightly overlapping the other colors to meld them together.

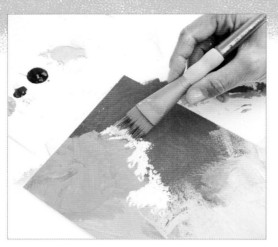

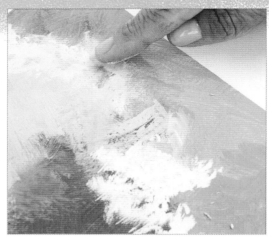

5 With a large dry brush held at a slight angle, dip the bristles into a heavy-body paint and tap up and down several times. Flip the brush over and dip and tap again to ensure you have loaded all of the bristle tips with paint.

Tap the bristles onto your palette a few times before tapping the brush onto your paper or substrate. Concentrate on tapping, not brushing, to create interesting marks with the bristles. Work the bristles all around the edges of your colored areas.

6 Working while the paint is still slightly wet, use your finger to gently move the paint around, rubbing it off in areas of your work. The heavy-body paint will add a nice patina over the brightly colored layers below, forming beautiful negative spaces.

You Got This!

Using one brush to add color to your work is a fun way to create not only interesting color patterns but also marks in your work. Working with a dry brush is what makes this technique successful. The dry bristles help form fantastic painterly strokes in the medium, which add great texture to your work.

You will love experimenting with the color wheel as you practice this technique, creating loads of amazing and colorful backgrounds for your future projects as you do. Don't forget to keep a record of your favorite color combinations in your journal. This will make a great reference when you are ready to apply this technique to your next big project.

7 After the paint has completely dried, layer your base marks. Use a china marker to create bold resist shapes. Keep the grouping small and the numbers odd. Remember this is a foundation layer, so work quickly and without much thought to placement.

8 In this step, continue building on the same marks. Use a no. 2 pencil to widen and define the marks you just placed by adding loose, fluid scribbles to their outer edges. A great way to get the best scribbled marks is to employ the help of your nondominant hand.

9 Build the rest of your base marks. Use a gel pen to create large pockets of repetitive marks. Adding paint and ink later will ensure these water-soluble marks move around. This helps create the illusion of erased and hidden imprints in the layers below.

10 Cut a simple mask out of card stock. Something large and hand cut will result in a less defined but more interesting shape. Holding the mask in place on your page, use a chip brush to begin adding rough dry paint strokes along the outlined edge.

» Make Your Mark: A Tip «

A note on making mud: It happens to all of us, and all artists fear mixing color at first. Just pay attention to complements, and you will have success. And if you do make mud remember this: There are many lovely shades of brown in this world.

11 Use a repurposed metal nail file to etch small lines into the still-wet paint and reveal some of the layers below. Keep a cloth or paper towel nearby and clean the tip of your file after every few lines you etch into the surface.

12 Add a few layered collage pieces using a glue stick. When dry, the residue from the glue stick will create a layer of slight resist that you can build upon in subsequent layers. Keep in mind we are still building a foundation, so more moving and less thinking still applies.

» Make Your Mark: A Tip «

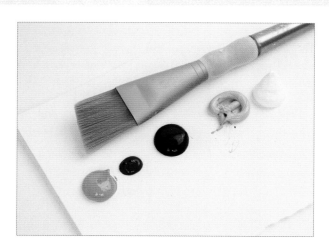

When working with your paints, try using assorted scraps of paper as your palette. Once finished, set the paper swatch aside to dry. Cut or tear these colorful samples up and use as collage pieces in your artwork to add pops of intriguing color and texture.

13 Add a final layer of color, resist and marks to your foundation. Using oil pastels is a great way to achieve colored resist marks. Scribble areas of the pastel onto your page and rub, then into the background with your fingers. You can layer and blend these for added depth.

You Got This!

As you work, remind yourself that you are building your layers with the intention of covering them up. Creating an overly busy and polychromatic foundation is vital to getting those top layers to really pop further into the process. Once you have conquered the fear of covering things up, you will discover that your chaotic underlayers are much more beautiful peeking through in bits and pieces.

Learn to be adventurous with your creative marks. If you have kept a detailed journal, you will be able to re-create your favorite imprints, marks and colors over and over again, so masking them won't seem quite so scary. In order to bring to life an even more visually pleasing layer, you will have to cover something up. Practice this technique in your journal so you're ready to uncover the mystery and joy of the process in your next big mark-making project.

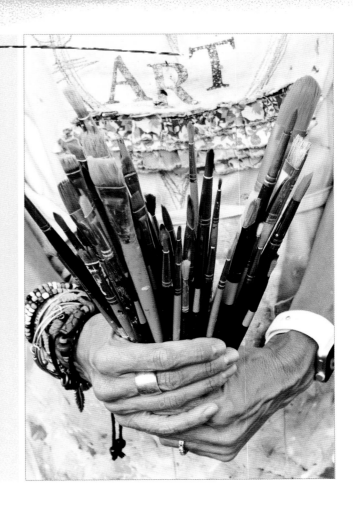

Monoprinting

ENDLESS POSSIBILITIES AVAILABLE

With limitless possibilities for creating color and marks, monoprinting can be a freeing exercise when it comes to experimentation and creativity. Whether you are building simple and predictable layers of color or exploring the unexpected results of layering marks, monoprinting will yield results that are as addictive as they are inspiring in nature. Think outside the box and try printing on oversized and recycled substrates. Surround yourself with a variety of interesting tools, as this will help to spark the creativity that makes printing so captivating. As you study the countless ways to layer paint and impressions, think about composition and color. Build foundations that are busy and colorful, then add layer after layer of paint and marks to create prints that are full of depth and dimension. Remember to dig deeper when you are printing and look for the hidden beauty in the smaller details of each printed piece. Observe the prints as a whole and then inspect them more closely. Divide the prints into smaller subsections and consider cutting and scanning them to use over and over again as multicolored and expressive backgrounds in all of your mixed-media projects.

WHAT YOU NEED

- ACRYLIC PAINTS
- BRAYERS, STANDARD AND DECORATIVE
- BRISTOL PAPER
- CARD STOCK
- DOWEL, SMALL
- GLAZING MEDIUM
- MARK-MAKING TOOLS, REPURPOSED
- MIXED-MEDIA PAPER
- PAINTBRUSHES, 1/2" (13MM) FAN, 1" (25MM) CHIP AND 2" (51MM) FLAT
- PRINTING PLATE (SUCH AS GELLI ARTS PRINTING PLATE)
- SILICONE CRAFT MAT
- STENCILS AND MASKS
- WATER

OPTION 1

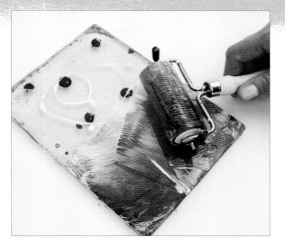

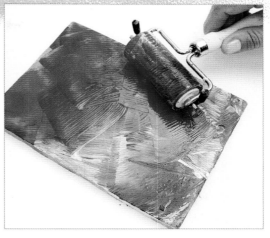

1 Add several drops of acrylic paint to a printing plate. If adding more than one color, be sure to choose complementary colors that will mix well to form a new color. Add a small amount of liquid glazing medium and begin blending the colors on the plate using a brayer.

2 Use the brayer to move the paint around and create wide painterly strokes and marks on the plate. Adding more paint will create thicker strokes. The glazing medium will open up the paint, allowing you a longer time to manipulate it on the plate.

3 Begin covering the entire surface of the printing plate with assorted stencils and masks. Choose a wide mix of shapes and sizes, and experiment with using only small portions of the stencils and masks as you layer them onto the plate.

You Got This!

As you work with your printing plate, test your color-mixing skills. Mixing and blending like colors directly on the plate will reward you with a variety of new colors to add to your journal. Make notes on how many drops of each color you add before mixing to keep an accurate record. This will allow you to replicate the colors when you wish to use them again.

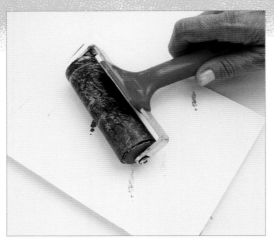

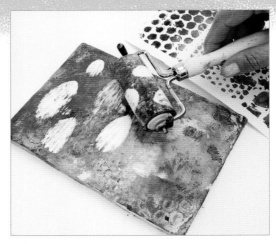

4 Lay a sheet of mixed-media paper on top of the stencil-layered printing plate and carefully use your brayer to roll over the entire surface. Use a gentle back-and-forth motion as you move the tool to ensure the stencils do not shift as you roll the brayer.

5 Gently pull your print off the plate and set it aside to dry. Remove the stencils. Add a few drops of white paint to the plate and roll the brayer over the paint, moving the tool in a forward direction only.

» Make Your Mark: A Tip «

Twist and turn the brayer as you work with it to create interesting movement in the paint before pulling your first print. The possibilities are endless with this tool, so you will want to have your journal at the ready for taking notes. For clean, bold stripes of color on the plate, remember to roll your brayer off onto a scrap of paper before beginning with a new color. Save the scrap papers to add to your collection of collage papers.

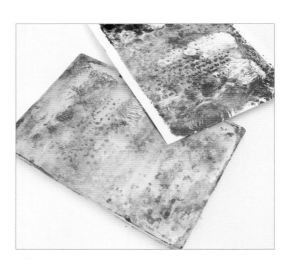

6 Lift the brayer off the plate. Lay the dry print back down on the plate and burnish over the entire surface of the paper. Pull the print and set aside to dry. Examine your printing plate. Notice the beautiful ghost image that is left behind on the plate. Lay a new sheet of paper down and pull the ghost print.

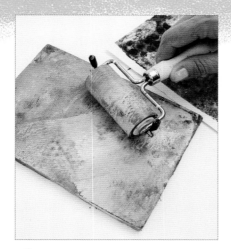

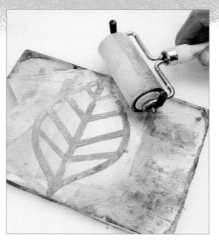

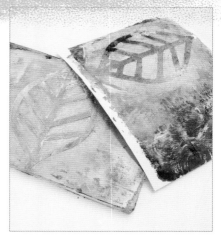

1 Let's experiment with covering things up. Add one or two drops of light-colored paint to your plate along with a few drops of glazing medium. Use a brayer to move the mediums around the plate until it is a nice semitranslucent glaze.

2 Lay a stencil down on the glazed plate and make one or two passes over the stencil. This will ensure it is secure to the plate as well as add a bit of the glaze to the top of the stencil. Lay your dry print face down on the plate and, once again, bray over the surface.

3 Pull the print. Notice how the glazing medium has added a bit of color and sheen to the print as result of mixing the medium with paint. By adding the stencil you were able to preserve some of the color added in the previous layers. Set the print aside to dry.

You Got This!

The best way to get creative with your prints is to work on several at one time. Use a new sheet of paper each time you pull a print until you have six or eight sheets in the rotation. Each time you load your plate with paint and marks, choose a new sheet from your rotation to pull your print. Cycling through these will help you create a wide assortment of interesting and unique monoprints.

Add marks and stencils to your plate each time you pull a print, then remove them again to pull the ghost image. Once you are comfortable with the process, you can up your rotation to include as many prints as your work surface will accommodate. Soon you will discover a variety of color combinations and mark-making tools that you love to use alongside your printing plate.

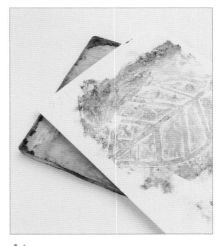

4 Take a clean sheet of paper and pull a ghost print from the plate. The glazing medium bonds with the drier paints on the plate, allowing them to be re-pulled in the subsequent ghost prints and creating beautiful and organic looking images.

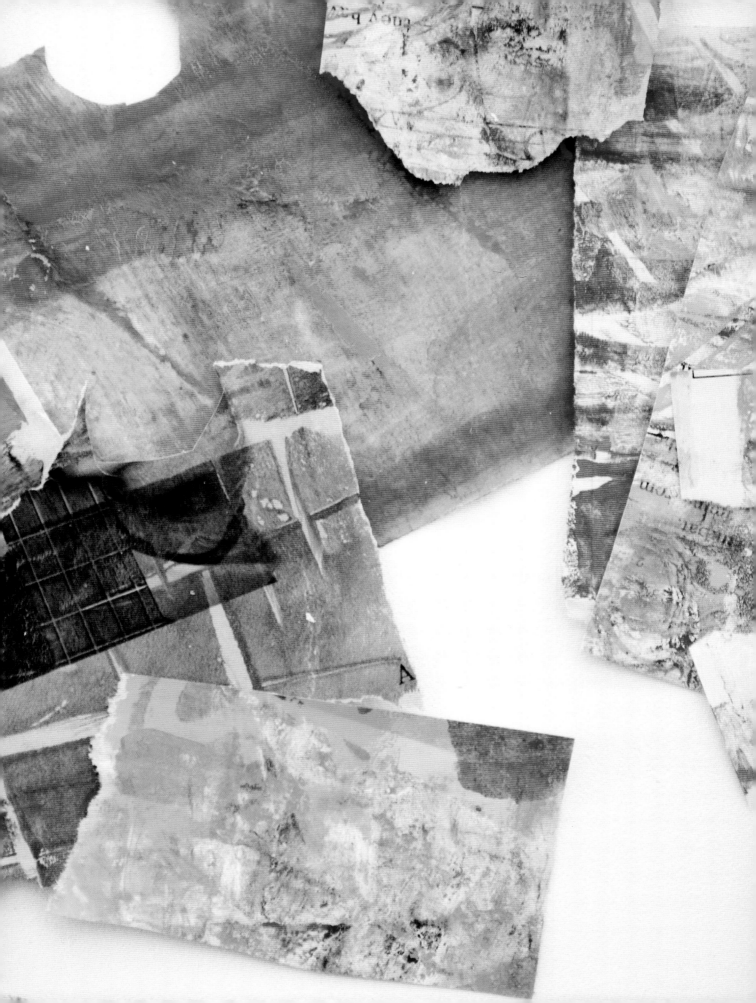

OPTION 3

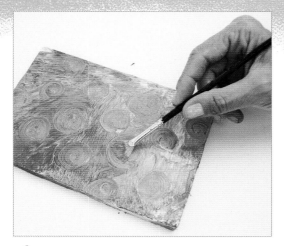

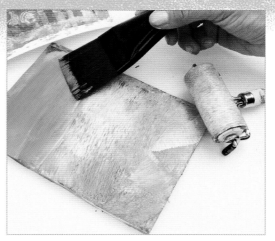

1 Load your printing plate with paint and glazing medium. Use a brayer to move the paint around, creating thick stroke marks. Use a fan-shaped paintbrush to create large rough circles on the plate. Twirl the brush around in a single motion for the cleanest marks.

2 Pull the print and note how the image may reveal ghost prints from previous pulls. Set aside and ink the plate using the remaining paint on your brayer. Add a thick stripe of color to one end of the plate using an oversized paintbrush.

» Make Your Mark: A Tip «

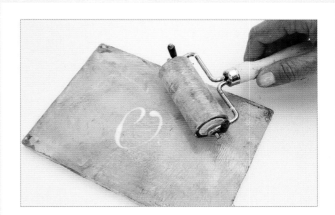

3 Use a decorative brayer to add even more marks to the inked plate before pulling a print. Layer your marks and make notes as you go in your journal. Even the faintest of marks added to the plate will add an element of interest to the final monoprint.

For abstract prints, clean your brayer on the printing plate each time you pull a print. Every few pulls, add a little liquid glazing medium and move the medium around, making sure to cover the entire plate. Pull the print and set it aside. Repeat each time you change paint colors and use the same sheet of paper each time you pull the print. This results in beautiful abstract monoprints.

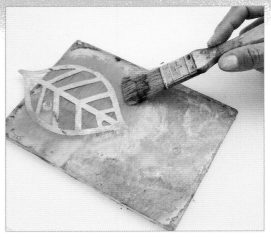

4 Continue to layer stencils and marks. Use the same print as you pull each subsequent layer to create a rich and vibrant print, but remember to turn the print in a new direction each time you lay it on the printing plate to distribute the colors and marks more evenly.

5 Add small patches of a colored glaze to your plate and layer with a stencil. To make the glaze, add one drop of paint and one drop of glazing medium to your palette and mix well. Add more glaze one drop at a time until your paint is semitransparent.

» Make Your Mark: A Tip «

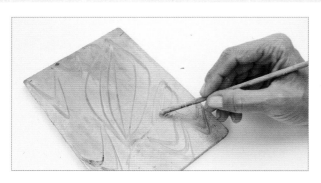

A quick way to create unique monoprints is to etch a design into the paint on your printing plate before pulling the image. Load your plate with a combination of colors and add a few drops of liquid glazing medium. Use a short piece of a dowel or other dull-ended tool, such as a popsicle stick or the eraser end of a pencil, to add a sketch or marks to the paint. Pull the print. Oftentimes the ghost images of these etched prints are the most interesting of all.

6 Pull the print and examine your plate. The colored glaze will appear to bead slightly on the surface. You can pull ghost prints at this stage or begin adding paint to the plate right away. You should see evidence of the ghost print in subsequent layers.

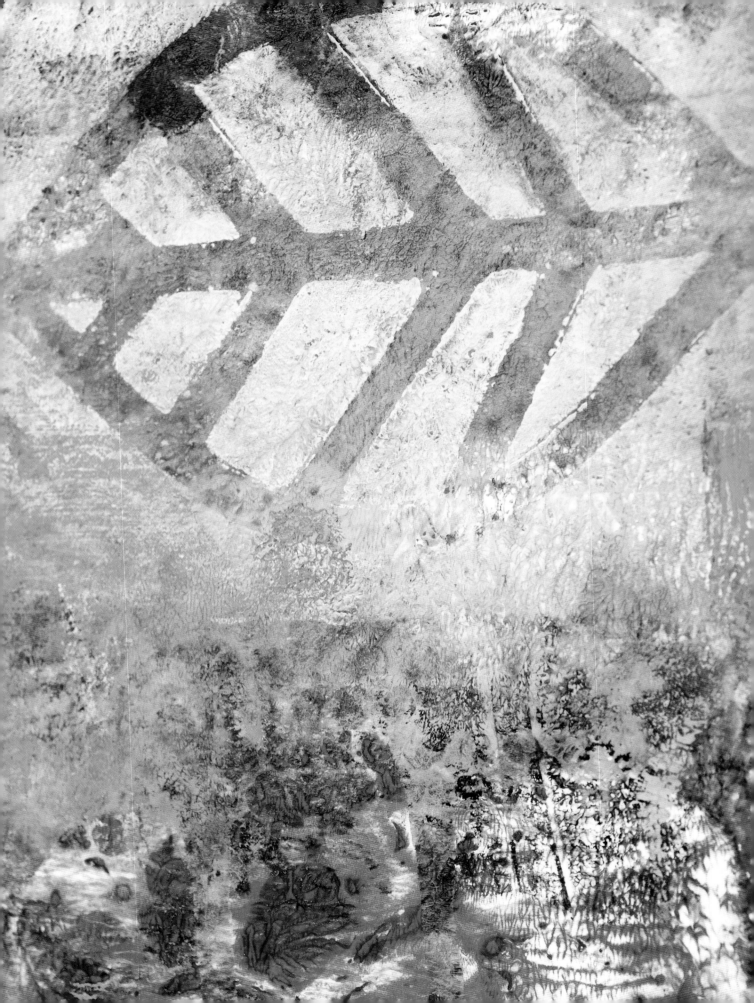

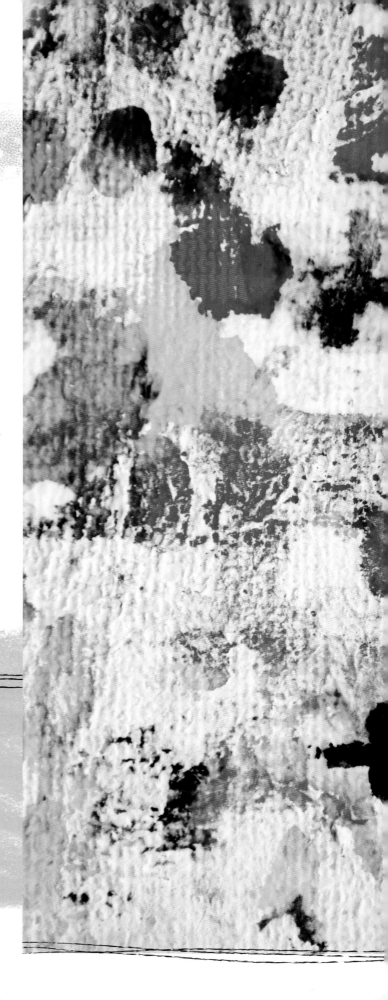

Resists

SOMETIMES IT'S ALL ABOUT THE MYSTERY

When it comes to working with resists and negative space, try to embrace the thrill of invisibility and let go of the control you are so accustomed to having when it comes to creating with color and lines. As an artist, it makes sense to want to visualize the process as we create. Seeing the images and marks form as we put pen to paper is what comes naturally. It is what feels right when we are creating. Stretch your creative instincts by working with mediums that are less visible, like masking fluids and rubber cements. This kind of creative exploration opens up a whole new world of mystery, allowing you to stumble upon unintentional curves and lines. Creating with imperceptible mediums in conjunction with your favorite mark-making techniques will help you to build an even greater and more unique sense of style.

WHAT YOU NEED

- » ACRYLIC PAPER
- » ACRYLIC INKS
- » ACRYLIC PAINTS, FLUID AND HEAVY BODY
- » GLASS DISH, SMALL
- » GLUE STICK, PERMANENT
- » HEAT GUN
- » MIXED-MEDIA PAPER
- » OIL PASTELS

- » PAINTBRUSHES, ANGLED, ½" (13MM) FAN, NO. 4 ROUND
- » PALETTE KNIFE
- » RUBBER CEMENT
- » STRETCHED CANVAS PANEL
- » WATER
- » WAX CRAYONS, ASSORTED COLORS PLUS CLEAR

WAX CRAYON & RUBBER CEMENT

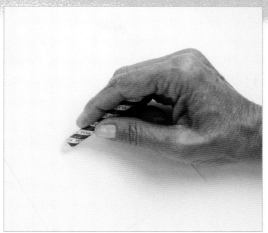

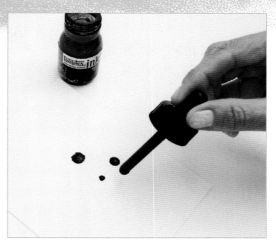

1 Use a clear wax crayon to sketch an image on a sheet of acrylic paper. Use a single quick motion to create a drawing that is loose and shows movement. Use your nondominant hand to keep your illustration fluid.

2 Add a few drops of undiluted acrylic ink to the paper over the top of your wax image. Acrylic ink is highly concentrated so just a drop or two will do fine. You can alternatively use a mixture of one part acrylic paint and one part water.

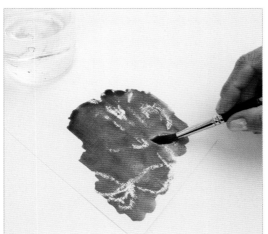

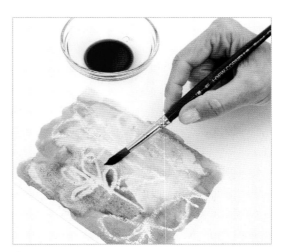

3 Dip a large round brush into a jar of clean water and begin to move the acrylic ink around on your page. Push each drop out from its center and toward the edges of the paper. You will begin to see the resist marks formed by the wax crayon. Let it dry.

4 Add more wax marks over the inked image. Dilute a second, complementary color in a small dish, mixing three drops of ink with one tablespoon of water. Mix well and begin to paint over your second wax image. Let the entire piece dry completely.

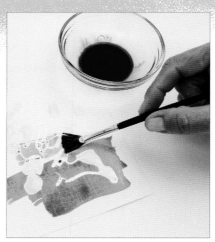

5 Using a clean sheet of acrylic paper, add several large drops of rubber cement to the page. Drag the brush just above the surface of the paper as it drips to create long, loose thread-like marks with the cement. Let it dry thoroughly before proceeding.

6 For a nonreactive watercolor effect, mix two parts permanent acrylic ink and one part water in a small glass dish and mix well. The more ink you use, the more opaque your ink color. For additional contrast when dry, use the ink undiluted.

7 Dip a fan-shaped brush into the ink and pull the ink across the top of the dry cement. Avoid overlapping the ink as you add it to the paper. This will help you to achieve the interesting marks the brush's bristles will leave in its wake.

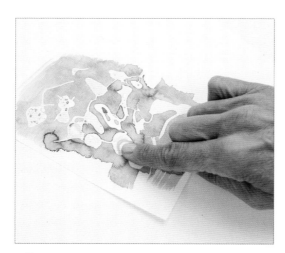

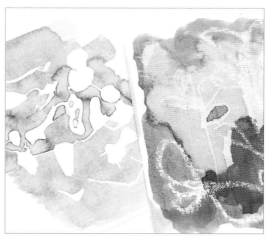

8 Once the ink is dry, make sure your hands are clean and free of ink. Use your index finger to gently roll the rubber cement away from you. Work slowly and tap any rubber cement shavings off the page as you go to avoid smudging your work.

9 Both the wax crayon and the rubber cement leave beautiful negative spaces in your work, allowing you to engage in the psychological concept of pareidolia. This is a phenomenon that stimulates your mind to perceive pattern and imagery where none actually exists. Use these negative spaces as a springboard for what your mind recognizes and bring it to life on the page with your tools and marks. Make notes in your journal about the concept and record your favorite imagery patterns to use as inspiration in future projects.

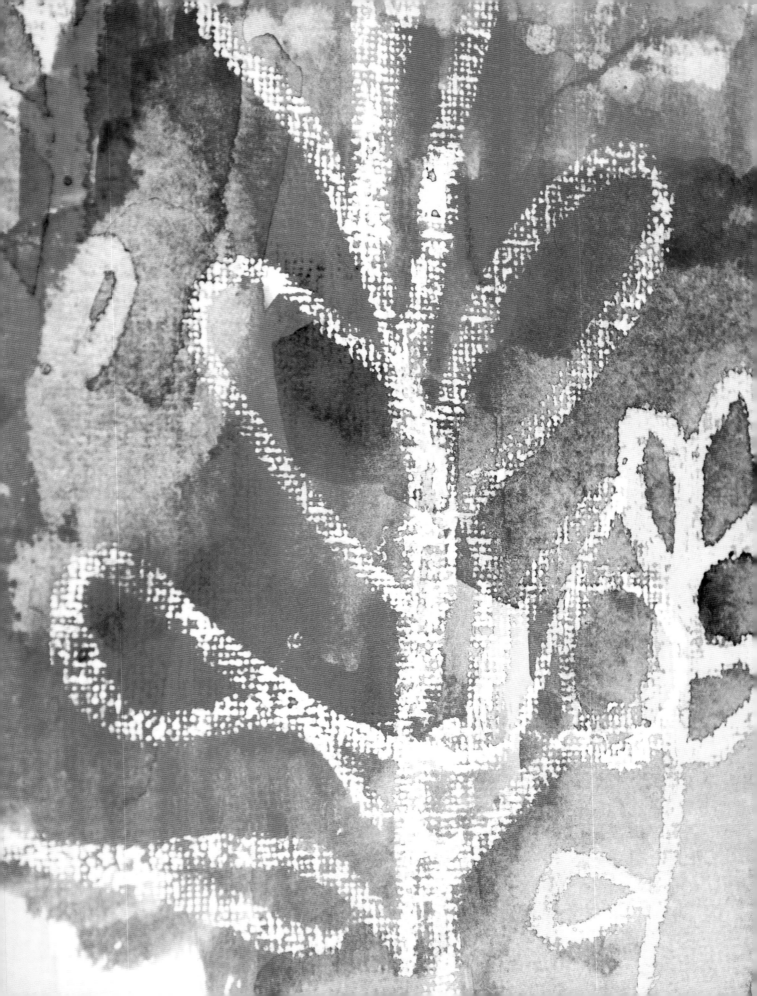

GLUE STICK & OIL PASTEL

1 Use a glue stick to sketch a rough border on a stretched canvas panel. Keep in mind that the glue will create a slight resist. Consider using a glue stick that rubs on in color but dries clear. This will help you see where you are applying the marks.

2 Let the glue dry for a minute or two. Add a few drops of fluid acrylic paint directly to your canvas panel. This viscosity of paint works well with the glue to create a crackle-type resist effect as the two mediums are layered.

3 Load your brush with water and begin to move the paint around on the surface of the canvas. Working while the glue is still partially uncured will ensure the greatest crackle effect. Clean your brush well with soap and water.

4 Heat set your canvas to speed up drying time and increase the crackle effect. Add loose scribbled marks with an oil pastel stick. Think about the rule of thirds and cluster your marks. Take your marks off the edge of the canvas.

5 Reactivate the oil stick marks you created using a heat tool. Once heated, let the canvas cool for a few seconds. Use your finger to move the oil pastel around and fan the edges of the marks out. Metallic oil pastels are great for adding reflective marks.

6 Use your finger to add heavy-body paint to the canvas. Concentrate on adding the paint to the edges of the panel and use a forward sweeping motion to apply the paint. This will keep the paint full of peaks and texture. Let it dry completely.

7 Add a second layer of resist marks. Use the tip of a palette knife to pick up a small amount of rubber cement. Tap the tip of the knife onto the dry canvas to apply the cement. This will create large, flat marks. Let it dry.

8 Add a second layer of color to your canvas. Add a few drops of acrylic ink to a dish and load a round brush with the ink. Press the tip of the brush onto the canvas repeatedly to cover the dry cement, creating interesting edge marks.

9 When the ink has fully dried, use a clean finger tip to roll and rub the dry rubber cement off the canvas, revealing the newly formed negative space marks. The first layer of color peeking through these marks creates the illusion of depth in your canvas.

10 To create a third layer of resist and build even more color and dimension, once again use your clear wax crayon to scribble over small areas of your canvas panel. Avoid adding the wax crayon over already visible negative spaces.

11 Use your brush to add color over the wax marks. Using a one part ink and one part water mixture works well and will create a semitransparent wash over the existing areas of your canvas. Extend the wash over the crackled portions of the panel.

12 Add final detail marks to your canvas by scribbling with a crayon. Scrub the edges of your panel with the tip of the crayon. Although traditional crayons are rich in color, they still provide a slight resist should you choose to layer over them.

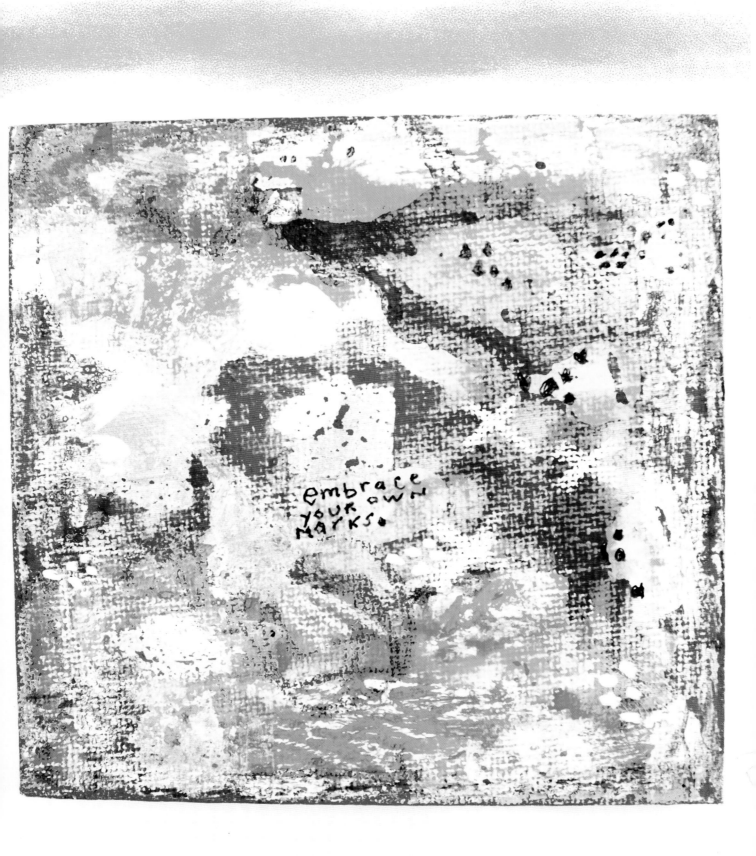

Transfers

SHIFTING IMAGE

Image transfers are wonderful in that they add so much character to your work. A perfect transfer, while lovely and clean, is much less interesting than the image that is only partial in its transfer. Manipulate your images before you create with them. Turn each one into something unique and eye-catching by simply cutting it down, reversing it or printing it all in one color. Use your newfound mark-making skills to create your own collection of images and print them out to have at the ready.

WHAT YOU NEED

» ACRYLIC PAINT, MATTE AND GLOSS

» CHINA MARKERS

» COLLAGE PAPERS

» GEL MEDIUM

» GEL PENS, METALLIC

» LASER-PRINTED IMAGE

» PAINTBRUSHES, ASSORTED

» PERMANENT ARCHIVAL METALLIC MARKERS

» PERMANENT MARKER OR PEN

» STRETCHED CANVAS PANEL

» WATER

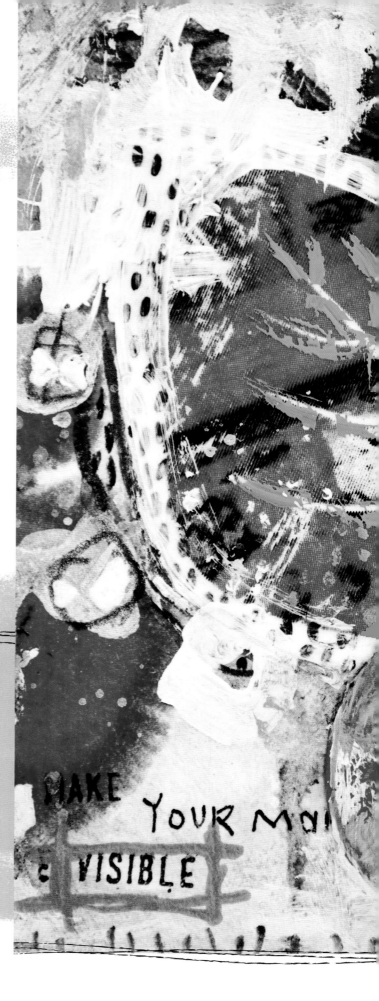

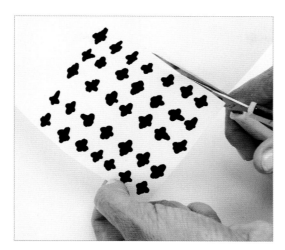

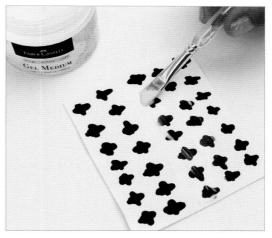

1 Print a photocopy of your favorite image or marks and cut it out. The laser toner sits on the surface of the paper, allowing the ink to be easily released when transferring the image. Most copy service centers can produce a laser copy for you.

2 Place your printed image ink-side up and add a thin, even coat of gel medium to the entire image. Let the gel medium dry. Add a second and third coat of gel medium to the image; be sure to let it dry between each application.

3 Add acrylic paint to a stretched canvas panel. Choose hues that are in the same color family and add a drop or two in each corner of the panel. Use a mixture of both fluid and heavy-body paints in matte and gloss finishes.

4 Use the one-brush technique you learned to move the paints around on your panel. Begin with one color and move it toward the center of the canvas. Blend and mix the edges of the remaining colors using the same brush until the panel is covered.

5 Add a coat of gel medium to the surface of your dried canvas panel. Brush the medium on in a smooth, even coat. Doing this will ensure a clean image transfer with the fewest wrinkles and air pockets.

6 Before the gel medium dries, lay your printed image face down on the canvas and gently smooth out any wrinkles with your fingers. Next, add a thin, even coat of gel medium over the top of the image and let it dry thoroughly.

7 Once the canvas and gel medium are completely dry, dip your brush into clean water and tap it onto the image. Repeat until the image is wet but not soaked. Use your finger to very gently massage the wet paper backing away from the image.

8 Brush away any remaining paper shavings. Use a damp brush to gently wash any remaining glue from the image, being careful not to scrub the image. Pat it dry with a clean cloth and seal the transfer with a thin coat of gel medium.

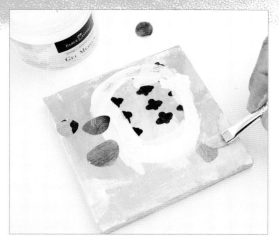

9 Add your foundation marks. Keep in mind that these projects are meant to be revisited, so concentrate on a few bold marks and layers. Use a small flat brush to add a large texturized ring of heavy-body paint.

10 Gather a few small collage bits and adhere them to the canvas panel with gel medium. Keep the pieces off center and look for shapes that are similar but slightly irregular in shape and size. Seal the top of the pieces with gel medium and let them dry.

»»» Make Your Mark: A Tip «««

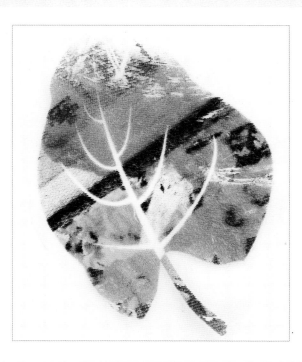

Try this super-simple and easy transfer technique when you want to create transfers on the go or have some ready to add to your travel art kit. Grab a favorite image. (Magazine quality images and photo booth strips work great.) Place a piece of clear packing tape over the image and use a flat-edged tool or popsicle stick to burnish the entire surface of the tape. Wet the back of the taped image and gently remove the paper. Once all the paper is removed, let your transfer dry.

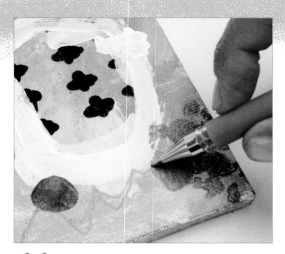 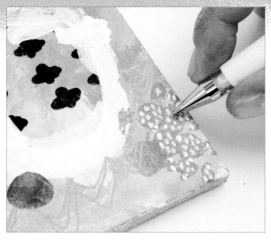

11 Use a metallic gel pen to add line work to your canvas. Make a note that the gel pen will reactivate with the addition of paint or water. This will create partial hidden layers and make your marks look less planned and more interesting.

12 Add lots of white to make your foundation pop with contrast. Again, use a gel pen to create small marks and to fill in your line work. Later, when you revisit this piece, you will scrub some of the pen work away with your paint and inks.

You Got This!

It is time to begin adding your final marks for this foundation. Remind yourself to create small detail marks that will peek through any subsequent layers. Add patches of brightly colored paint, and once dry, add tiny marks using a metallic marker.

13 For nonreactive detail marks, use a permanent marker or pen to add bits of journaling and lots of repetitive marks. These pen marks will peek through even with the addition of most paints and inks due to the dark color and permanent qualities.

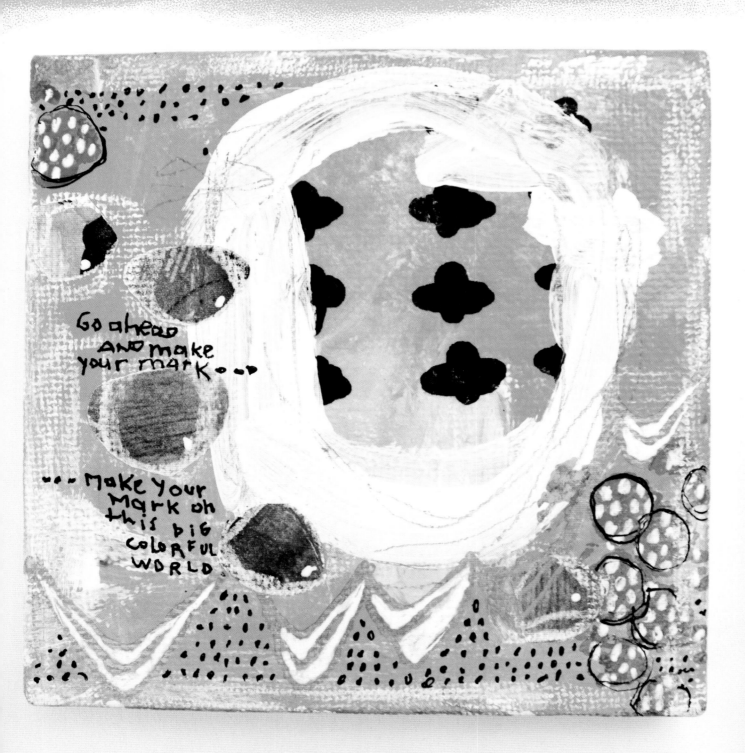

Go ahead
and make
your mark...

... make your
mark oh
this big
colorful
world

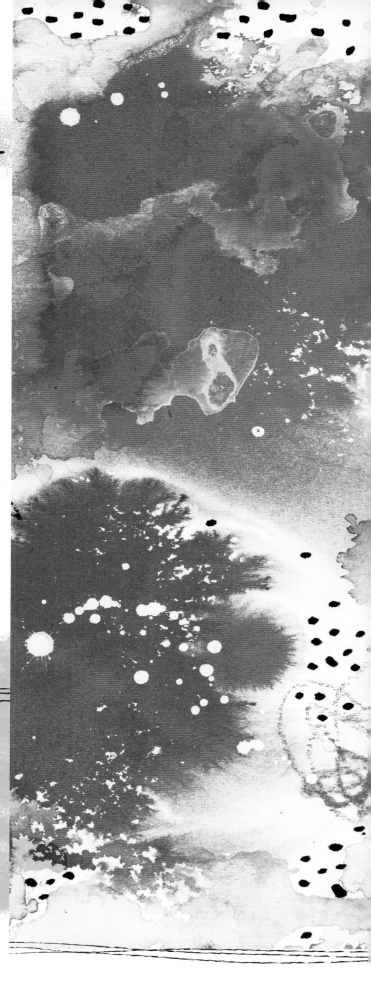

Freeform Marks

DIG IN AND GET MESSY

Creating like a child might be all it takes to recognize yourself in artwork. Whether you pick up a crayon and scribble your way to mark making or line your colors up and go to town making rainbows, you are likely to discover what feels good when you let go and create with abandon. This is the time to ignore the rules and just make art. Scratched lines, scrawled circles or simply placed marks are all techniques that reined us in as kids as we colored our way through art class. Dig in and get messy when you are creating, and you are sure to find your fingerprint.

As you work through the following exercises and experiments, find your own unique fingerprint in the mark-making world and consider creating a collection of your practice works. One of the biggest hurdles for artists is hanging onto work that is less than beautiful, but in keeping these learning pieces, you will discover more about yourself and your sense of design and style. Pull from this collection to build your own art journals. The foundation marks and color on your study pages will make for inspirational backgrounds and pages. Once these papers are a part of your journal you will find them to be useful tools for tackling the blank page.

WHAT YOU NEED

» ACRYLIC CRAFT PAINT, WHITE GLOSS

» BRISTOL PAPER

» EASTER EGG DYE PELLETS

» GLASS DISH, SMALL

» LIQUID FOOD COLORING

» PAINTBRUSHES: 1" (25MM) CHIP, DETAIL AND LARGE ROUND

» SPRAY BOTTLE

» VINEGAR

» WATER

» WATER-SOLUBLE BLOCKS

» WATER-SOLUBLE CRAYONS

» WATERCOLOR PAINT

» WATERCOLOR PAPER

OPTION 1

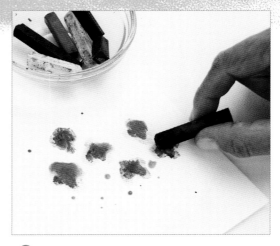

1 Prime your bristol paper by adding a layer of white gloss craft paint. Dry brush a thin coat onto small areas of the page and let it dry. This builds a multi-toothed finish on the paper, allowing the pigments to both move along and grip the paper.

2 Dip a water-soluble block into clean water and wet the tip thoroughly. Draw or sketch with the wet end of the block to create chunky marks of color. Resist the urge to smooth out the color, instead letting it pool and dry on its own.

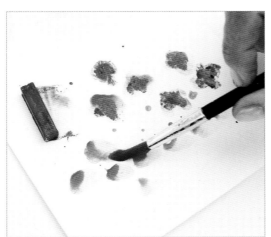

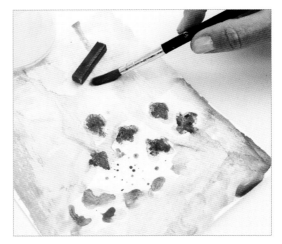

3 Use a paintbrush loaded with clean water to pull color off the water-soluble block. Rub the wet brush across the top of the block several times to saturate it with color. Press the brush onto your paper and lift straight up to create colorful pooling marks.

4 Once your puddled marks are dry, use the techniques learned in steps two and three above to add more color to the background of your page. Note how the color grabs the areas of painted and unpainted bristol differently. Make notes in your journal about the process.

1 Dip a large round brush into clean water and draw large rings onto a sheet of watercolor paper. You will want to make sure that the water is standing on the surface of the paper, so work in a few small areas at a time.

2 Dip your brush into watercolor ink or egg dye (refer to the tip below) and lightly touch the tip of the brush to the pooled water ring. Notice how the water absorbs the ink and moves it out from the brush tip following the trail of water.

≫ Make Your Mark: A Tip

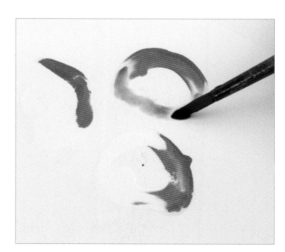

Collect an assortment of egg dyeing pellets and use them to create organic inks. Place two or three tablets in a glass dish and crush them into a fine powder using the end of a wooden chip brush. Add a teaspoon of water and mix well. Continue adding a few drops of water at a time until the mixture is the desired shade. Add a teaspoon of vinegar to bind the pigment. Note that this is not a lightfast or color permanent ink. Experiment with this new medium in your journal. Add any remaining crushed dye powder to small vessels for future use.

3 Clean your brush and dip the tip into a second color of paint or egg dye. Again, lightly touch the tip of the brush to the water ring, avoiding the first color and, instead, working where the water is clear. Let the colors run together naturally as they dry.

OPTION 3

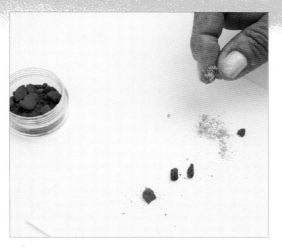 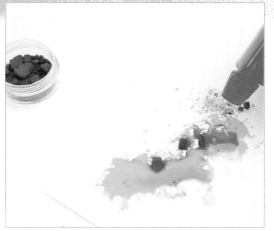

1 Begin with a clean sheet of watercolor paper. Sprinkle a small amount of the crushed egg dye powder (refer to the tip on page 112) onto the paper. Larger pieces of the powder will take longer to dissolve and create deeper colors.

2 Use a spray bottle filled with clean water and white vinegar to mist the dye powder. Let the colors run together and form a trail on the paper. Let it sit for a few moments before lightly misting again. Tip the page to move the trail and create drip marks.

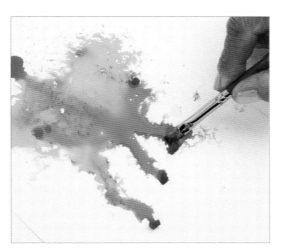

3 Use a small detail brush to move the remaining larger pieces of powder around the page. Re-wet them using the water mister or let them sit to create deep pools of color. Use the brush to move any undissolved pieces off the paper. Let it dry.

OPTION 4

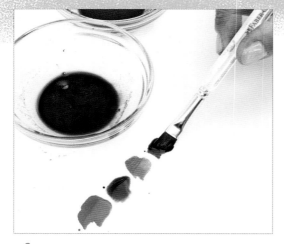

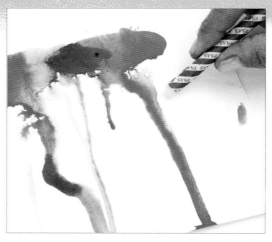

 Mix up a few batches of organic ink using the crushed dye powder. (Refer to tip on page 112.) Use a small angled brush to pick up the ink. Press the brush down near the top edge of the paper to create a small pool of color. Repeat with additional colors.

2 Tip the page onto its edge so that the newly formed pigment pools run and drip. Let the ink dry before moving. Once dry, use a clear wax resist crayon to make small clustered marks on the page, concentrating on the un-inked areas.

You Got This!

Don't let the organic nature of these tools stop you from creating with them. Even if you only use them to explore the endless possibilities of color, texture and design, you will be learning along the way. Always keep your journal handy to record any new findings, both good and bad. These notes will save you time down the road as you work on larger projects and want to refer back to your favorite marks and color choices.

Think about starting a dedicated art diary just for use with these nontraditional supplies. Draw, paint and sketch with these organic mediums and watch how they morph and change over time. Add notes to each page that include the creation date and supplies used, such as food coloring, dye powder and other repurposed tools, substrate, light exposure and drying time. Leave a space for additional notes. Predetermine a future date when you can check back and make any added updates on fading and color degradation. Experiment with other homemade recipes and add these notes to your new organic art diary.

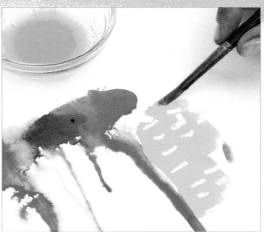

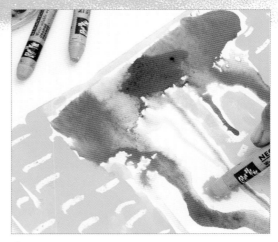

3 Use a clean paintbrush to pick up a new color of dye and brush it over the resist marks. Note how the ink flows over the marks and pools near the edges. Continue adding the ink over the remaining wax marks and let it dry.

4 Note how the drips formed thirds on the page. Use these as a guide and begin to add a few larger marks. A water-soluble crayon is a great tool to use for adding some scribbled knots to an un-inked area of the paper.

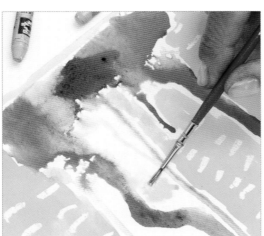

5 Use a detail brush loaded with clean water to move some of the crayon pigment around. Adding more water than you need will allow the pigment to puddle, creating interesting line work around the edges of the marks. Let these marks dry.

6 Add a final layer of color to this foundation piece. Sprinkle a small amount of the dye powder on areas of the paper. Mist with clean water and let the powder dissolve slowly. Watch and make notes on how it moves around the existing resist marks. Let it dry.

You Got This!

Mark making is more than just a term used to describe the patterns we create with them. It is a process within our artwork that builds expression, defines shapes and adds final details. Most often, mark making is attributed to a finishing layer in your artwork, but it can also be an elemental technique for building the underlayers of your work.

Mark making forms a bedrock in your work that is rooted in pattern and color. Arranging a base that is busy and polychromatic can be simple if you have the right tools and will lend impetus to your creative process. So yes, use your marks freely throughout the entire creative process because it will be these base layers that you pull from when creating an inspiring and well-arranged piece.

»»» Make Your Mark: A Tip «««

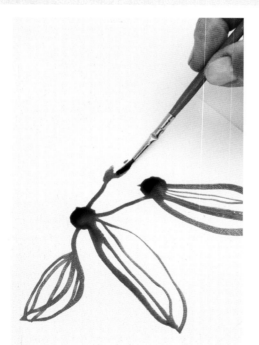

Grab your daily art diary and get ready to explore liquid food coloring. These highly opaque pigments are nontoxic and the perfect viscosity for polishing your detail and line work skills. Add a few drops of the pigment to a clean sheet of watercolor paper and use a detail brush to drag the organic ink out and away from the drip. Do a few trials using a blind contour technique and your nondominant hand. Add the date and other notes to your journal and remember to check back at a later date to observe how the ink has changed over time.

Revisits

A CHANGE OF VIEW MAKES ALL THE DIFFERENCE

By now you have gathered your tools and are familiar with key objects that seem to be your go-to mark makers. You have been keeping a journal of your marks and how they impact the composition and form of your artwork. You have explored color and experimented with a wide range of repurposed implements; maybe you even created a daily art diary for recording observations on the effects of light and time on organic paints and inks. And you have taught yourself to take a step back. You are finding your way and learning to enjoy the marks that define you as an artist.

Now let's take the time to revisit it. Pause for a moment and collect your journal, your daily art diary, your collection of experiments. As you review your work, take a moment to consider it from a new perspective. This can be as straightforward as rotating your work or as forward thinking as covering it up. Stepping away has the power to reignite your creativity, to call to mind ideas and inspiration that were not present when you first sat down to create, but it is not a given.

Try to disentangle yourself from the false illusion that revising your work will always bear the fruit of a masterpiece. You will, as all artists do, have moments where you are filled with self doubt, but practicing what you love is the best way to overcome this fear and to accept that some days we make beautiful art, and some days we simply make art.

WHAT YOU NEED

- » ACRYLIC INKS
- » ACRYLIC PAINTS, HIGH FLOW (GOLDEN)
- » BABY WIPES
- » CHINA MARKERS
- » COLLAGE PAPERS
- » DAMP CLOTH
- » DELI PAPER
- » GEL MEDIUM
- » GEL PENS
- » GLUE STICK
- » MAGAZINE PAPERS
- » METAL NAIL FILE
- » PAINTBRUSHES, INCLUDING 1" (25MM) CHIP
- » PALETTE KNIFE
- » PENCILS
- » SCISSORS
- » TEXTURE PASTE STENCILS
- » STRETCHED CANVAS, 6" × 8" (15CM × 20CM)
- » WATER
- » WHIPPED SPACKLE OR TEXTURE PASTE

1 Gather your supplies. Use the materials list as a guide only. This is the time to explore your toolbox more deeply, pulling out the instruments that excite you the most. Leaf through your journal for inspiration and collect your favorite collage bits.

2 Prep your canvas panel by adding gel medium with a chip brush. Be sure to apply an even coat using the bristles of the brush to work the medium into the rough surface of the canvas. This will help your collage pieces adhere more smoothly.

3 Add your collage papers. Smooth out the papers as you place them on the panel, adding a final coat of gel medium over the top of each piece to seal it onto the canvas. A mix of colorful monoprints and text papers make a nice contrast.

4 Think about how you want to revisit your foundation artwork. Freehand cutting it into a shape and adding it to your canvas is a fun way to alter the sample. Try to avoid ordering the alteration and, instead, let chance guide your scissors.

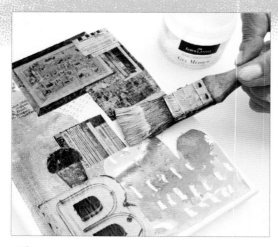

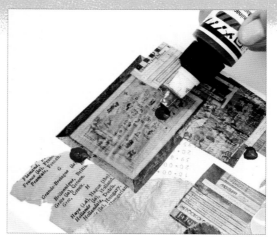

5 Adhere your cut foundation artwork to your canvas using gel medium and smooth out the air pockets using your brush or scraper tool. Continue to layer additional collage pieces until your panel is mostly covered. Let it dry.

6 Once your canvas is dry, add a few drops of high-flow acrylic paint or ink to your panel. Add the pigment to both collage and bare areas of your canvas to begin building cohesion within the piece. Tip the canvas to get paint or ink moving.

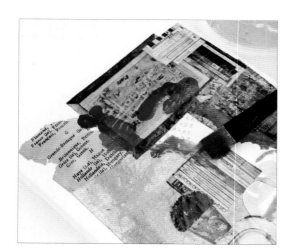

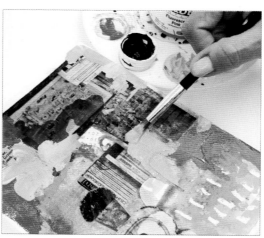

7 Dip a paintbrush in clean water and use it to begin helping the paint or ink move around the canvas. Push along the edges of your collage bits to create dark edges. Add more water to thin out the ink and make it more translucent.

8 Use your canvas as a guide and fill your palette with several shades of acrylic paint that complement your existing colors. Use a large dry brush to add paint to your panel. Concentrate on connecting the paint to your collage scraps.

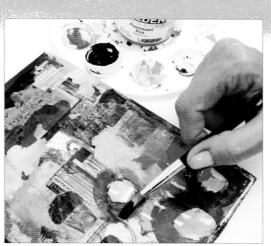

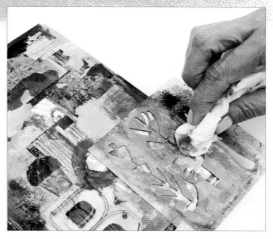

9 Pull in a dark or contrasting color by adding large, simple shapes. Create a border on your canvas by dragging the loaded brush along the edges of the panel. This is a big step in covering things up, so work slowly and set your sights on the end result.

10 Work in reverse and subtract some of the freshly added color. Position a stencil over the still slightly wet paint. Holding it firmly in place, use a baby wipe or damp cloth to carefully remove the paint through the stencil opening. Let it dry and repeat.

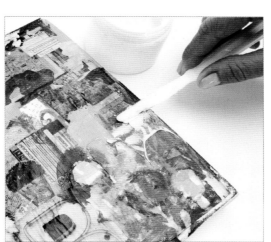

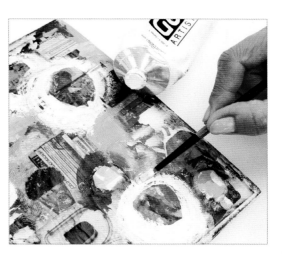

11 Use a palette knife to pick up a generous amount of whipped spackle or texture paste and place the knife flat down on the canvas. Using firm, even pressure, drag the loaded knife across the surface of the panel to spread out the medium. Repeat and let it dry.

12 Make your canvas come to life by adding highlights. Load a small brush with heavy-body white paint and scribble large ring-like shapes to create lots of painterly texture. Let the paint dry completely before adding all your detail marks with pens and pencils.

You Got This!

The continual building of layers in a piece is what gives it life. Use your pens and pencils to add tiny detail marks, words and line work to your canvas. Work in reverse to subtract marks, and create the illusion of wear by using a wet brush to lightly scrub some of the marks away.

Words are easily the most valuable marks you can make as an artist. It is your word that creates a definite and lasting fingerprint on a piece and signifies your work as your own. One or a hundred, these written details add significant depth and meaning to any work of art.

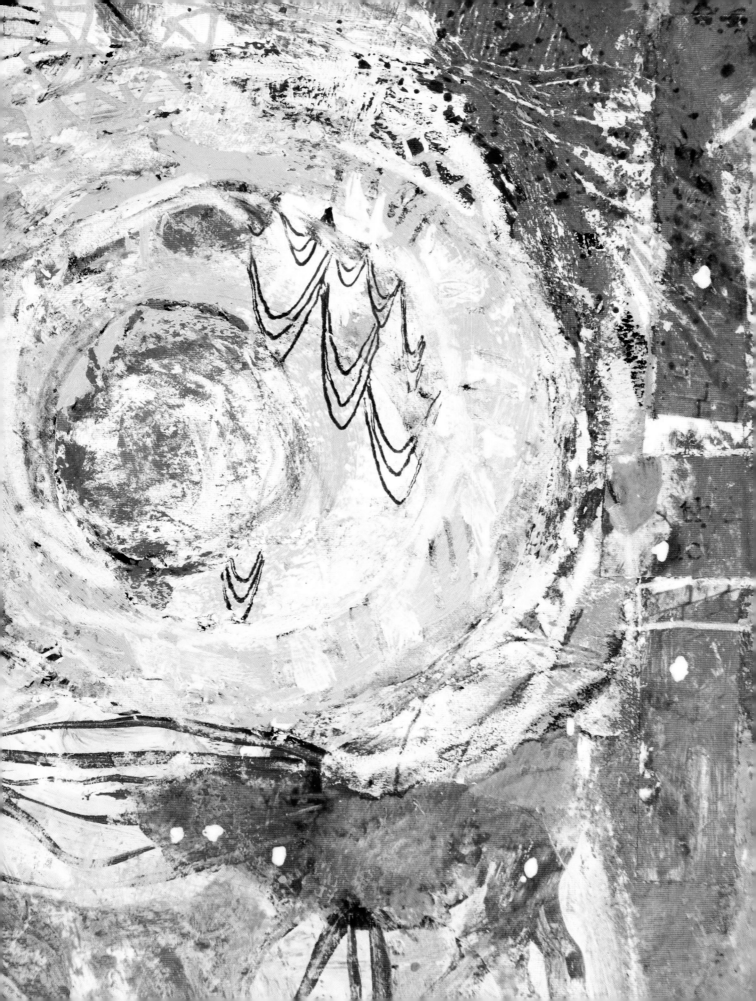

Projects
IDEAS FOR PUTTING IT ALL TOGETHER

4

Now that you have filled your toolbox and explored dozens of mark-making techniques, you are ready to put your own unique and artistic fingerprint to the test. When it comes to creating mixed-media projects, a great rule of thumb is this: read, experiment, refine and create.

Read about the project. What intrigues you about the process? What do you love about the end result? What would you do differently?

Experiment with the process. Along the way, discover what you love about the approach and make notes of what you would change to create something that is more in line with your way of artistic thinking.

Refine the approach. Modify and adapt the process using your own set of tools and the knowledge you have collected as a mark maker and mixed-media artist. Consider how you might add your own fingerprint to the design to better shape the process into something that reflects your own artistic style.

Create something that defines you as an artist. In short, learn what you can about a project and take from it what you love. Leave the rest behind, and in doing so, you will make art that is beautiful and distinctly you.

Working Small

PINT-SIZED ART

Working small is a safe size for many artists. There is so little space to fill that the fear of facing the blank slate isn't as common. Small amounts of color and tiny marks are often all it takes to create a full and busy background. Composition is simpler to achieve, and the creative process is quicker, making it the perfect size art for becoming more familiar with your style and unique.

Learning to embrace the joys of working small—artwork in minutes or hours rather than days, small pieces that pack a powerful and colorful punch and the ability to work on several pint-sized pieces at the same time—is simple and rewarding. There is so much to love about small artwork that goes beyond the creative process. Easily swapped, traded and mailed, tiny art forms are endearing simply for their collective nature. One only has to create a tiny work of art to know how captivating these pieces are, catching the attention and heart of both the sender and the recipient of such small-scale goodies.

Working small is the perfect outlet for both practicing and mastering your collected and favorite mark-making techniques. But just because art is pint-sized doesn't mean it has to stand alone. Unlike larger works of art, multiples of these compact pieces can easily be arranged to create larger, more stunning finished projects.

WHAT YOU NEED

- » ACRYLIC PAINTS
- » BALLPOINT PEN
- » BRAYERS, STANDARD AND DECORATIVE
- » CARD STOCK
- » COLLAGE PAPER
- » EMBROIDERY THREAD
- » FIBER PAPER
- » GEL MEDIUM
- » GLAZING MEDIUM
- » INKED FABRIC
- » NEEDLE
- » PAINT PENS, ASSORTED
- » PAINTBRUSHES
- » PAINTED PAPER TOWELS
- » PALETTE KNIFE
- » PERMANENT PENS, ASSORTED
- » PRINTING PLATE, 3" (8CM) SQUARE
- » SCISSORS
- » STAMPS, ASSORTED
- » STRETCHED CANVAS PANELS, TWO 3" (8CM) SQUARES
- » WATER-SOLUBLE CRAYONS

1 Place two or three drops of acrylic paint onto the small square printing plate. You can alternatively use a larger plate and ink more than one stretched canvas panel at a time. Use a smooth brayer to move the paint around, blending the edges of each color together.

2 Trim card stock scallops that are slightly larger than your printing plate. Place the positive piece on one end of the printing plate and the negative piece on the opposite end of the printing plate. Get creative with your card stock and trim other interesting positive and negative shapes.

3 Carefully place your miniature canvas panel onto the printing plate and press down firmly but gently. This will ensure your canvas panel does not shift during the printing process. Use your fingers to press down on the inside of the panel as well as along the reinforced edges.

4 Have another small stretched canvas panel ready to take a second impression. This panel will pick up the ghost print from the plate. Working on more than one panel at the same time will allow you to create multiple pieces that are similar but not identical when fully completed.

5 Once both panels have been printed, set them aside to dry completely. Carefully remove the card stock pieces from the printing plate and set them aside to dry as well. Begin to fill in the masked areas of your panels with color using an assortment of small brushes and acrylic paint.

6 Gather an assortment of papers and cut out small pieces that are similar in both size and shape to the masked areas on one of your panels. Layer your collage pieces using gel medium to adhere them to the canvas panel. Add a topcoat of the gel to each piece and set it aside to dry.

7 As you set your first canvas panel aside to dry, pull your second canvas panel into rotation. Working over the dry ghost print, add a layer of color with a palette knife. Concentrate on the negative areas of the panel and apply the paint in an organic fashion. Let it dry.

8 Still working on the second canvas panel, add more color and texture using a water-soluble crayon or similar tool. Hold the crayon loosely and scribble the edges of the entire panel. Leave the marks as they are or use a small brush to add water and move the crayon marks around.

9 Trim simple shapes from collage paper and, again using gel medium, adhere them to your canvas panel. Remember, you are working small so one or two shapes should be enough to add a nice focal point. Add a topcoat of gel medium to seal the paper and set it aside to dry.

10 Use a paint pen or marker to add color to a small detail stamp. Press the stamp along the edges of the panel where it is reinforced with wood. To create a stamped impression near the center of your panel, use your fingers to support the canvas from behind to avoid stretching out the material.

11 Fill in any remaining negative spaces with a translucent glaze. To do this, mix a 1:1 ratio of acrylic paint and glazing medium on your palette. Adding extra paint will create a more opaque glaze while adding more glaze will increase the translucency. Apply with a brush and let it dry.

12 Finish your second panel's rotation with a pop of color. Use a small dry brush to add thick rings of paint to your collage pieces. Scrub the paint on for a more organic look. Bring your first panel into the rotation and add color to it using the same technique. Let both dry completely.

13 Work on your panels side by side, as a complete unit. If a piece needs any highlights, use white acrylic paint and a small brush to add thick marks that are full of texture. Use the same paint but different marks on each canvas. Let the panels dry.

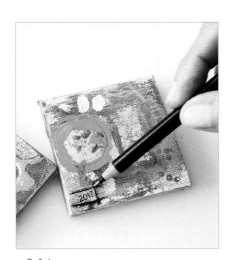

14 A basic ballpoint pen can add nice glossy marks over the top of dry acrylic paint. For a bit of contrast, choose a black pen and lightly scribble along the outlines of your collage and painted shapes. Stamp a word or number and scratch loosely around the edges with the same pen.

You Got This!

When working with multiple panels at the same time, alternate between them often during the creative process. Once each one has been fully printed and dried, have a system ready for applying the remaining marks to the panels. For example, collage and stamp one panel, then switch to the second panel where you might add texture paste and ink. This simple method of alternating the panels every few layers keeps you creative and always looking at your work with fresh eyes.

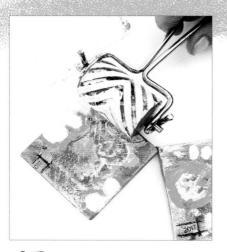

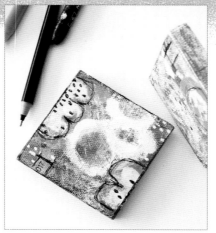

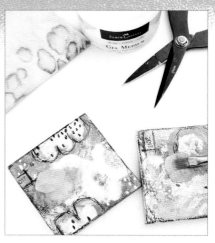

15 Add paint to your palette and run a decorative brayer through it several times to ink it well. Now quickly, in one fluid motion, roll the inked brayer over the surface of the first canvas panel. Without re-inking the brayer, roll it over the surface of the second panel for a ghost-like print.

16 Add your final detail marks using pens and pencils. Both black and white marks add a final pop to each canvas and are a simple repetitive mark that tie the two pieces together nicely. Don't forget to add color and marks to the edges of your stretched panels for a finished look.

17 Cut small shapes out of inked fabric or fiber paper. Painted paper towels and baby wipes are great choices. Use gel medium to adhere the trimmed scraps to the panels and let them dry. Add a final topcoat of gel medium to the fiber paper and let it dry thoroughly before moving on to the next step.

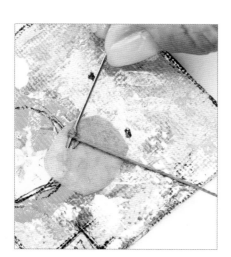

18 Use embroidery thread to add a few tactile marks to your panel. French knots are simple and create a lot of dimension. Alternatively, an assortment of the most basic hand stitches will add a lot of color and texture to your pint-sized artwork. (See Hybrid Hoop Art on page 138 for more on French knots.)

You Got This!

Think you aren't ready to work on more than one miniature at a time? Try the assembly line method. Line your tiny panels up in a row and work on them from one end to the other. Begin by printing or painting the first one and move down the line. Try not to reload your plate or brush with ink or paint until necessary as this will keep things looking more organic and less forced. If you work with a brayer or other large tool, such as a palette knife, begin on one panel and continue in one motion over the next panel or two to create marks that are similar yet not identical, again keeping your work from looking like it was created in a factory.

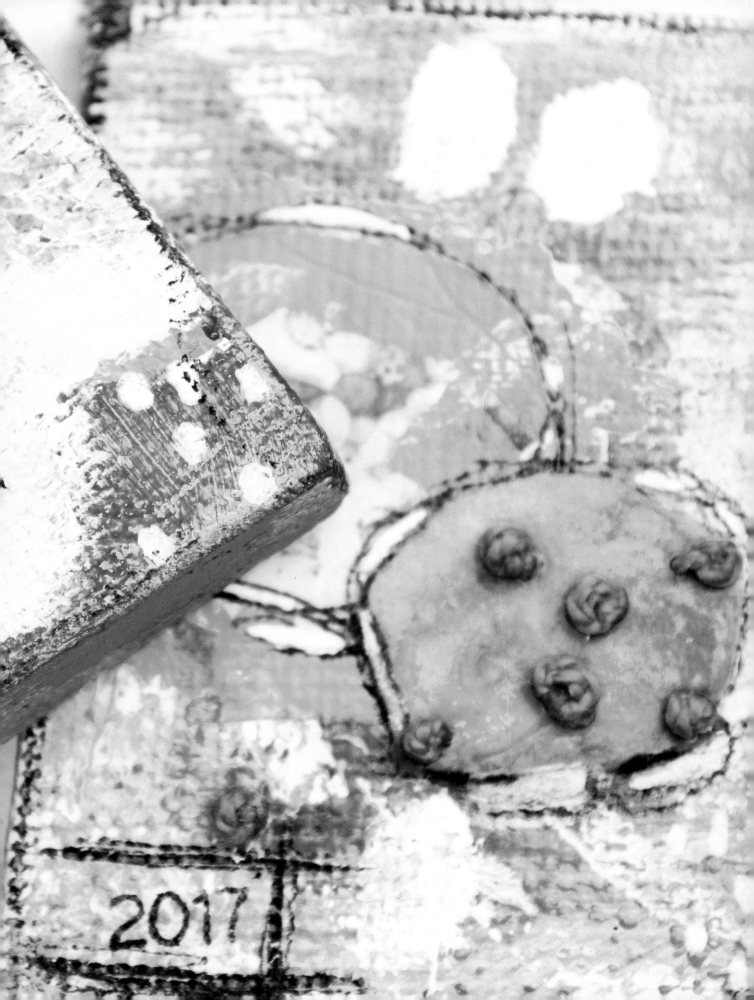

Pareidolia

FINDING PATTERNS WHERE NONE EXISTS

As an artist, you think visually in terms of things. A perfect example of pareidolia would be thinking you see a man in the moon. You know this to be false, yet when you glance up you see the image plainly. Your mind is registering imagery where none actually exists.

Recognizing pareidolia in your artwork will become more evident the longer you experiment with the basic process for laying its foundation. Only you can decide whether or not to build on the image in your artwork. Most often with pareidolia, the image, which is so evident once discovered, begs to be front and center, but there are no set rules when it comes to incorporating these discoveries into your work.

The simple and organic application of color to a page is what helps to form the random images that are easily found when the right thought process is applied. Shaping your work around these visual discoveries is a great exercise in focal point and sketch work experimentation.

Pareidolia serves to produce instant and organic focal points, some abstract and others clearly image-like. Finding a focal point in your artwork using this process takes the guesswork out of creating one. Most helpful when creating large and abstract pieces, you need only to drip paint or ink to suddenly realize you are seeing images.

The process is also helpful when it comes to becoming more adept at sketching. Consider all the images you would normally not attempt to draw. You might not be comfortable marking out the lines of a human face or exotic animal, yet when you perceive them through pareidolia you have a foundation for that very outline. This creates the perfect trail for you to follow and explore. When it comes to pareidolia, there is no way to recreate any one image so it is vital to remember this one thing: Whether your finished artwork yields the results of what you first perceived matters less than the path you took once it was discovered.

WHAT YOU NEED

- » ACRYLIC INKS
- » ACRYLIC PAINTS
- » ALCOHOL BLENDING SOLUTION
- » ALCOHOL INKS
- » CHINA MARKERS
- » DROPPER
- » GEL PENS
- » GESSO, CLEAR
- » GLAZING MEDIUM
- » PAINT PENS, ASSORTED
- » PAINTBRUSHES
- » PENCILS
- » SANDPAPER, FINE GRIT
- » SOFT CLOTH
- » SPRAY BOTTLE
- » WATER
- » WATER-SOLUBLE CRAYONS
- » WOOD BURNING TOOL
- » WOOD PANEL

1 Prep your wood panel. Begin by selecting a large flat brush. Apply an even coat of clear gesso to the entire surface of the panel. Let it dry. Sand lightly and add a second coat. Alternatively, you can use white gesso to prep the surface of your substrate. Let the panel dry completely.

2 Once your panel is completely dry and sanded, add clean water to a spray bottle and mist the entire surface. The heavier the water pools, the more your ink will move around. Alternatively, you can use a dropper or heavily loaded paintbrush to add water to the surface of your panel.

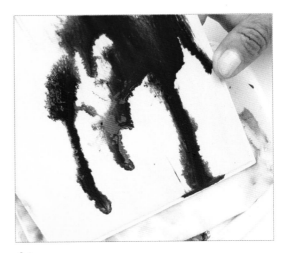

3 While the water on your panel is still wet, add several drops of acrylic ink and let the pigment move and shift organically. A high-flow acrylic paint will work similarly for this step. When using acrylic paints, you may need to re-mist the surface once the paint is applied.

4 Tilt your canvas to create even more movement with the ink and water mixture. Use a gentle rocking motion left and right and up and down to allow the color to creep across the entire surface and off the edges of the wood. Lay the panel flat and let it dry thoroughly.

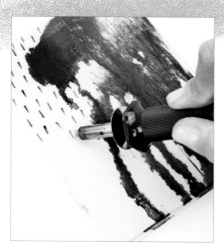

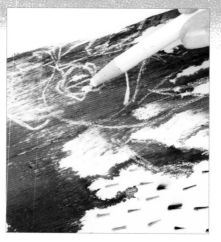

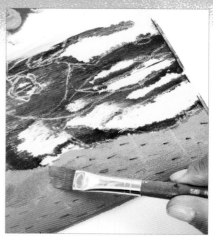

5 Add background texture and marks using a wood burning tool. (Use caution and the proper protective gear as this tool can become extremely hot.) Use the tip of the tool to etch or draw small impressions in the areas surrounding your inked pareidolia marks.

6 Examine your work for imagery. Rotate the panel and look at it from different perspectives. Once you discover a pattern or focal point, use a china marker to quickly sketch a rough outline of your image. Add more detailed sketch marks as desired before moving on to the next step.

7 Fill in the areas surrounding your sketch marks with acrylic paints. Blend and mix several complementary paint hues with the same brush. Choosing an angled brush will allow you to work right up to the edges of your sketch lines with ease. Let the paint dry.

You Got This!

Pareidolia will manifest itself differently for each artist. When you begin to experiment with this concept in your artwork, look beyond the color. Often the pattern or imagery will present itself in the negative spaces of your work or in an overlapping combination of the two.

As you create, remind yourself that you are free to embrace or ignore the marks that present themselves. As with all mark making, take a step back and look at your work with fresh eyes. Your inspiration will shift throughout the creative process. Each time you revisit your work, allow yourself to reexamine the previous layers.

8 Take a moment to examine your work more closely. Note the changes in your imagery once the surrounding areas have been filled with an assortment of marks and color. If desired, use more color and a detail brush to alter your pattern into something more refined during this time.

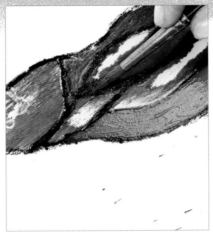

9 Think about covering it up. Work a layer of white paint over the top of your colorful background to prepare the surface for an aged look. Each layer and mark added from here forward will contribute to the final visualization of the pattern or imagery discovered through pareidolia.

10 Use a water-soluble pencil or crayon to outline your sketch further. Begin filling it in with color. Use a detail brush to apply layers of acrylic paint to add depth and texture. Use the initial layer of ink as a springboard for your perception. Let each new layer dry completely.

11 Stretch the boundaries of your outline. Get creative and make the imagery unique and quirky. Pareidolia is the perfect experiment in stepping out of your comfort zone. Do something different and make notes in your journal of any new discoveries during the process.

12 Use a variety of pens and pencils to add some detail marks to your image. This is the perfect time to incorporate your go-to marks, adding an element of yourself to the project. Let the layers dry. Remind yourself to step away and revisit your work from a fresh perspective.

You Got This!

Throughout this process, some questions to answer in your journal might include: What comes next? Did you use the image as a springboard for practicing sketch work? Did you find yourself altering the image throughout the process? Did you find more than one image in your work and, if so, did you bring both to the forefront? Make a record of things you would do again and parts of the process you would avoid next time.

13 Cut and bend a small square of sandpaper around your finger in a U shape. Firmly rub the white areas of your panel to remove the paint. Stop often and use a soft cloth to brush aside the paint dust. Continue sanding until you achieve the desired worn look on your panel.

14 Rotate your wood panel and incorporate a bit of additional color. To begin, add a few drops of an alcohol blending solution to an area of your panel. Once dripped, the solution will be difficult to see, so be sure to focus on the area where you wish to add a layer of color.

15 Working quickly so the blending solution does not dry, add a few drops of colored alcohol ink in the same area where you dripped the solution. Let the ink move and pool on its own within the solution, creating a second layer of pareidolia in your artwork.

You Got This!

Pareidolia will inspire you like no other mark-making technique, drawing you out as an artist into a new world of creative exploration. Each time you put ink to paper, you will be rewarded with a fresh and original series of marks to consider. Test your skills with these imagined patterns, and you will find yourself creating outside your comfort zone and learning new things about yourself, your marks and your art along the way

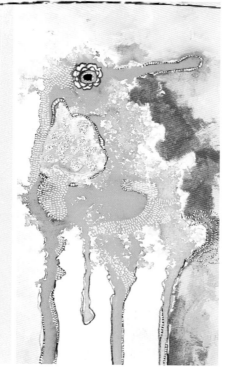

16 Incorporate final details by adding all of your favorite marks. China markers are great for adding marks over the top of several layers, including the sanded areas. Paint pens add a glossy mark easily and offer intense opaque color. Metallic gel pens glide over the paint and ink smoothly.

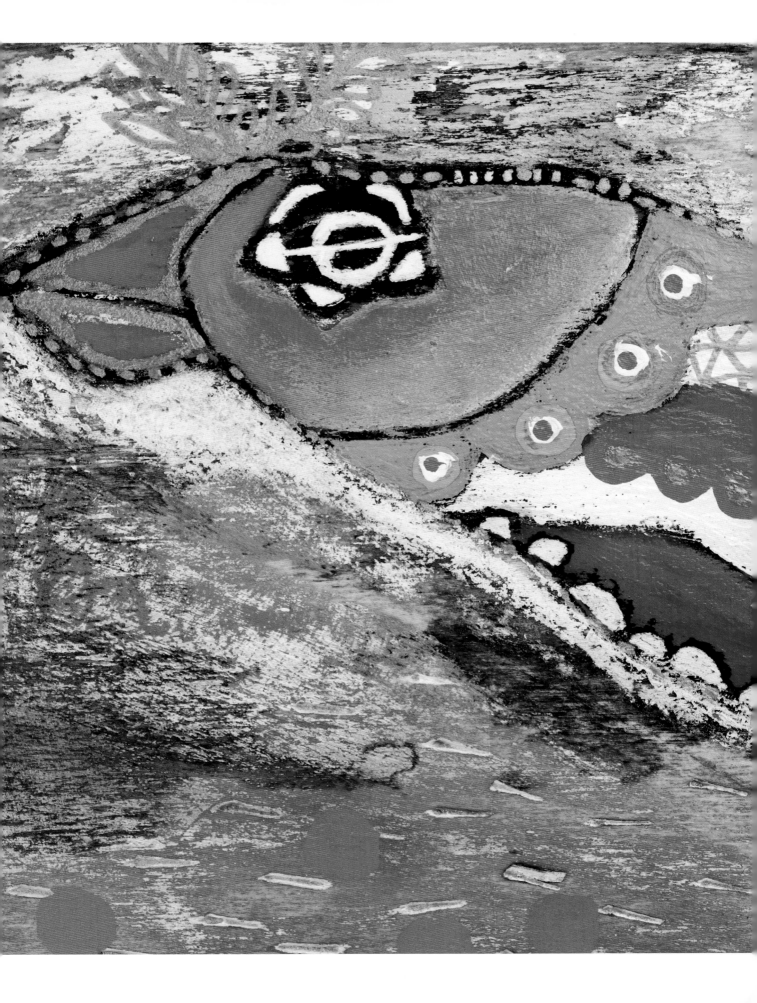

Hybrid Hoop Art

CREATING DIMENSION WITH MARKS

Many artists are easily tricked into thinking they can only explore one art form at a time. Hybrid Hoop Art is a mixed-media project that defies this notion and encourages you to incorporate your loves of all art forms as you create. As a mark maker, push yourself to explore fabric, paper, paint and stitching in a singular creative work. Build and layer as you would with paint and pens using these new tools and discover an entirely new world of texture, dimension and mark making.

As you work through the different stages of this form of mixed-media style, you are continually springing from one technique to another, which in turn propels your creative vision to new levels. Dyeing fabric produces organic colors that encourage you to mix new colors on your paint palette. Forming patterns on paper with paint can spark new ideas for stitched marks on fabric.

Layering assorted textures and mediums together adds an element of interest to your art that a single medium cannot achieve and allows you to exercise your mark-making skills without being a master of any one technique. Push aside your fears of mixing mediums and revel in the freedom that intermingling these skills can bring to you as a mark-making mixed-media artist.

WHAT YOU NEED

- ACRYLIC INKS
- ACRYLIC PAINTS, FLUID AND HIGH FLOW (GOLDEN)
- COTTON FABRIC
- CLOTHESPIN
- EMBROIDERY FLOSS
- EMBROIDERY HOOP
- EMBROIDERY NEEDLE
- GLASS JAR
- IRON
- PAINTBRUSHES, ASSORTED INCLUDING ANGLED 1" (25MM)
- PAPER TRIMMER
- PENCIL
- PENS, ASSORTED
- PERMANENT MARKERS
- SCISSORS
- SEWING MACHINE
- SPRAY BOTTLE
- THREAD
- WATER
- WATERCOLOR PAPER, 11" × 14" (28CM × 36CM)

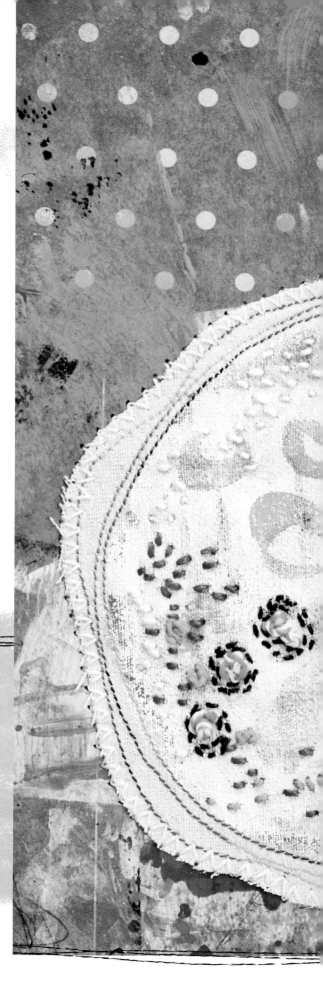

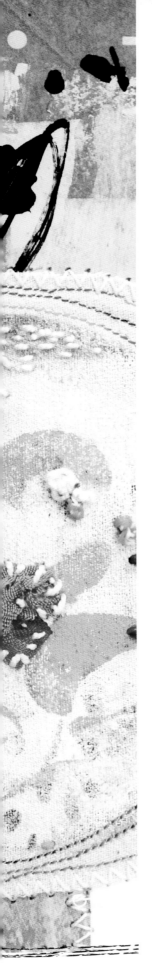

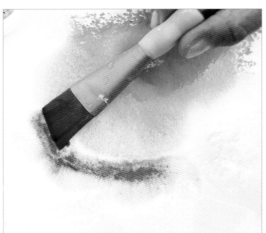

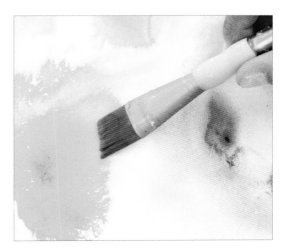

1 Spray a large sheet of watercolor paper with clean water, letting it pool heavily in some areas. Mist other areas of the sheet lightly. Dip a large brush in high-flow or fluid acrylic paint and tap the brush in the center of the pooled water. Let the water pull the paint around the sheet.

2 Use a clean brush and add a second and third color of paint to the sheet. Lightly re-mist the sheet with water to create even more movement in the paint across the page. Do not scrub the brush but, instead, tap it down on the page and let the water do all the work of mixing and blending.

3 The sheet will be heavily saturated with paint and water. Let it dry completely before moving on. Once it's dry, add several marks using colored ink pens. Confining the marks to the negative spaces on your painted watercolor sheet will add interest to this paper layer of your project.

4 Set the painted sheet aside and cut a square of cotton fabric that is two times larger than the embroidery hoop you will be using to stitch your marks. Fold the fabric square in half. Begin at the edges and roll the fabric into a small, tight cylinder shape. Clip the top of the roll with a clothespin to secure it.

5 Fill a glass jar with a few inches of clean water. Add three to six drops of acrylic ink. Adding two complementary colors of ink to the water at one time adds interest. Let the colors mix organically in the jar. The more ink you add, the more intense your fabric color.

6 Place the rolled fabric tube into the jar and watch it begin to absorb the pigmented mixture. Resist the urge to move or reposition the fabric roll. Let it sit one to two minutes. Use the clothespin to lift the roll and flip it, submerging the dry end in the ink. Let it sit one to two minutes more.

7 Press your dyed fabric square flat with an iron. Loosen the screw on your hoop and pull the two rings apart. Lay your pressed fabric on top of the inner ring (no screw mechanism) and carefully place the outer ring (with screw) on top. Tighten the screw. Tug slightly on the fabric to make it taut.

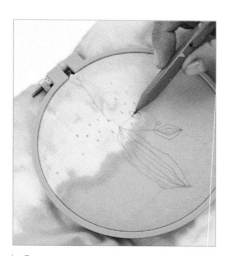

8 Use a pencil to add marks to your fabric. Simple marks are best for stitching knots while sketched images can easily be outlined with a series of simple straight stitches. Keep the marks away from the edges of the hoop to make them easier to reach when you are sewing.

You Got This!

Whenever you are working on a project, remind yourself often that there are no rules, just guidelines or starting points. Experiment with dip dyeing fabric, alternately letting it dry and re-dipping to create ombré patterns. Fold and roll your fabric into an array of shapes before dipping to unleash random and intricate designs. Fill several jars with different hues of ink and layer the fabric with color as you dip.

Encourage your inner artist to really play with each new lesson or technique before adding another layer to your project. Create notes in your journal about the exercises and give yourself a wide range of ideas to choose from as you move forward with the process.

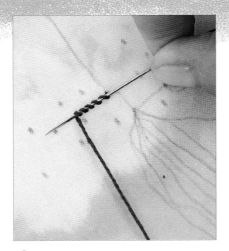 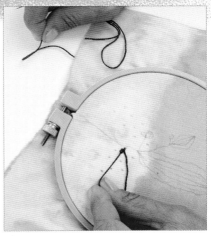

9 Create a series of French knots over the simpler pencil marks. Pull your floss through to the front side of the fabric and wrap it around the needle. For oversized marks, wrap the floss around the needle five times, holding the floss tight with your other hand as you work.

10 While holding the floss taut, push the needle back down through the fabric right next to where the needle originally came up. Continue holding the floss until the needle is all the way through the fabric. Tug gently on the needle to tighten the knot fully. Repeat to cover all of your simple marks.

11 To change colors, tie off the thread on the back side of your fabric and begin again with a new strand of floss. Cluster your knots to create dimensional marks. Blocks of color intermingled with small pops of white make your knots both colorful and visually pleasing.

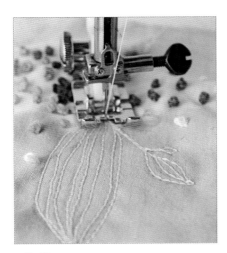

12 Remove your work from the hoop and place the fabric under the foot of your sewing machine. Use a simple straight stitch to trace your sketched design. As a substitute to machine stitching, you can use simple hand stitching to outline your image. Remove your fabric from the machine.

You Got This!

Adopt all of the techniques and combine them in any number of ways when creating hybrid art. Adding a tactile element to your next painted canvas, or painted marks to your next stitched project, will embolden you as an artist and continue to add to your pool of growing inspiration. Use your journal as a place for recording all of your hybrid projects and the merged techniques and mediums that you experiment with as you are creating.

13 Lay your stitched and knotted fabric square on a protected surface and press out any wrinkles created by the hoop. Avoid flattening your knots by working the iron tip around them as you go.

14 Use your embroidery hoop as a template. Grab a pencil and trace a large circle around your stitched and knotted fabric work. Once traced, trim the circle from the fabric with scissors.

15 Place the fabric circle on your sheet of painted watercolor paper and move it around until you find a position you like. An off-center arrangement is frequently the most visually pleasing.

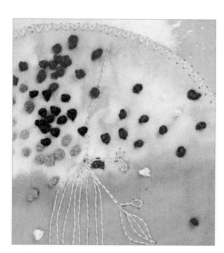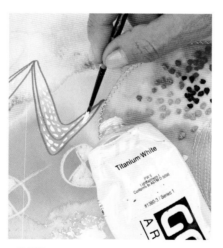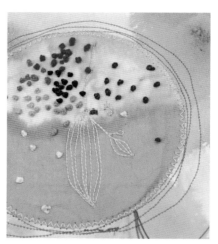

16 Place the sheet of watercolor paper back on your sewing machine and use a zigzag stitch to secure the edges of the fabric circle to the paper. You can also hand stitch the circle to the page.

17 Add marks with paint, pens and pencils. Work the circle into the design element by using it as a focal point. Create marks that hinge on the fabric for balance and grounding. Let the marks dry.

18 Make your fabric circle pop by adding a final round of stitching detail to the page. Use brightly colored thread to stitch organic rings that overlap your marks and highlight your focal point.

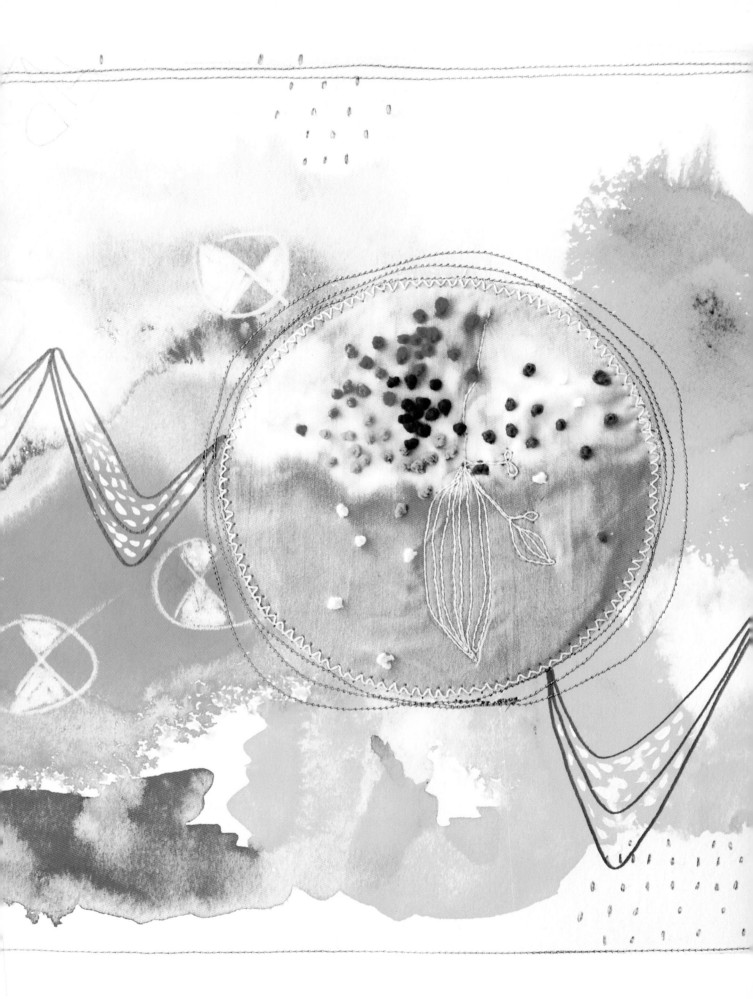

Working Big

A CLAN COLLABORATIVE

The thought of working big can be intimidating, but the moment you, as an artist, entertain the idea of a large-scale project, your whole outlook on creating will shift into this unbounded creative challenge. Every scope of the process will open up new doors for inspiration and imagination.

Every single component of such a substantial undertaking will require you to think out of the box. From tools, to timing, to composition, you will be tasked with reconfiguring your everyday method for putting brush to canvas. Working big means thinking big. A sizable piece of work will mean much more than just collecting extra paint or bigger brushes. When setting your hand to create a bigger-than-usual work of art, take the opportunity to look around you. Find and use tools that are interesting, oversized and repurposed. Experiment with reshaping your everyday art marks into ones that form an eye-stopping pattern and design. Study your favorite techniques in a new light and discover the freeing feeling of working on a much larger scale.

One of the great advantages of working big is the opportunity to share in the creative experience. Big projects take much longer to accomplish but offer you more opportunities when creating, such as teaming up with other artists and creators. Collaborative projects have the power to offer endless inspiration for all artists involved. Allowing each creator his or her own time at the canvas is the best way to let go of the control we feel when making art. In relinquishing, we learn to appreciate what each contributor has to offer. Each time you approach the canvas, you are met with a rush of originality and vision. By giving up control, you can choose, instead, to revel in the fundamental beauty that will result from letting the work morph naturally with each artist's newly added marks. A larger canvas means more room for ideas, inspiration and collaborative beauty.

WHAT YOU NEED

- » ACRYLIC INKS
- » ACRYLIC PAINTS, FLUID AND HEAVY BODY
- » ARTIST SPONGE OR MAKEUP WEDGE
- » BBQ BASTING MOP
- » CARD STOCK
- » COLLAGE PAPERS
- » DROPPER
- » FLY SWATTERS

- » FOAM DISH SCRUBBER
- » GEL MEDIUM
- » GESSO, WHITE
- » OVERSIZED CARDBOARD TUBES (SUCH AS GIFT WRAP TUBES)
- » PAINTBRUSHES: DETAIL, SMALL FLAT, SMALL ROUND, ASSORTED CHIP BRUSHES (1"–4" {3CM–10CM})
- » PENCILS, ASSORTED

- » PENS, ASSORTED
- » POOL NOODLE SLICES
- » SCISSORS
- » SPRAY BOTTLE
- » SPRAY PAINT
- » STRETCHED CANVAS, 36" × 48" (91CM × 122CM)
- » WATER
- » WATER-SOLUBLE CRAYONS

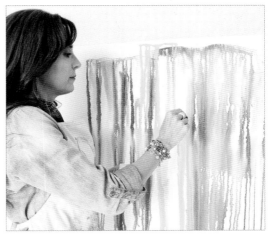

1 Begin working big by prepping your large stretched canvas. Brush on an even layer of gesso, coating the entire surface. Once dry, spritz the panel heavily with water. Add drops of colored acrylic inks to the top edge of the panel and allow to it bleed into the water. Let it dry.

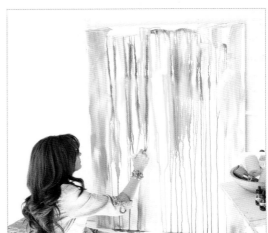

2 Load your palette with several complementary colors of acrylic paint. Heavy-body paints will add lots of texture. Use a large dry 2" (51mm) brush to fill in the negative spaces around the ink marks. Scrub the paint into large circles and crosshatch shapes before letting the paint dry.

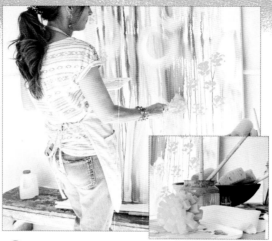

3 Dip a soft sponge scrubber into heavy-body acrylic paint and push the head of the scrubber against the canvas to create large, multifaceted imprints. Cluster the marks, confining them to specific areas of the panel. Allow extra drying time for these heavily textured marks.

4 Hold a plastic patterned fly swatter flat against the canvas. Add color through the openings using short even bursts of spray paint. Move the swatter around, overlapping the pattern as you go. For added interest, try spraying the paint through small portions of the swatter in some areas.

5 Tear an assortment of collage papers into large pieces. Place them in a basket or bowl and stir them up with your hands. Blindly grab pieces and collage them to the canvas using gel medium and a 1" (25mm) paintbrush. Layer the pieces, adding several clusters throughout the canvas.

6 Add contrast to your canvas in the form of shape and color. Consider using a very deep blue or dark brown in lieu of black to create a unique distinction. Use a round brush to paint thick, texturized, scribbled circles. Use the shapes to join the edges of the collage pieces. Let it dry.

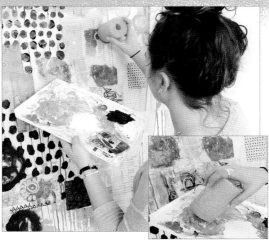

7 Step back from your canvas and examine it from a new angle. What areas are calling for something bold or interesting? Add big, texture-loaded marks using a contrasting color of paint and a big round brush. Push the loaded brush onto the canvas to create painterly fingerprints. Move the brush upward as you lift it from the canvas to create wells in the center of your marks.

8 Remember to flip and rotate your canvas as you work. Do this often to gain new perspectives into the larger scale design. Trim a piece of foam pool noodle into a large ring-shaped stamp. Pounce the paint-dipped stamp onto the canvas repeatedly to create a sequence of marks that vary in texture and opacity. Reload the stamp and repeat in additional areas of your canvas.

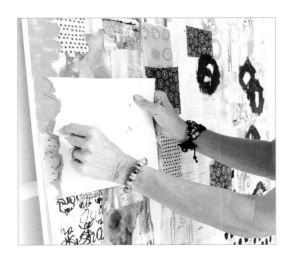

9 Working big will require you to conquer your fear of covering things up. Each new layer you apply to your canvas will mean overlapping and joining the previous layers. Use card stock to trim a large scallop mask. Hold the mask flat against the edge of your canvas and pounce acrylic paint through the openings with a repurposed foam makeup wedge or artist sponge. Let it dry.

» Make Your Mark: A Tip «

Learn to walk away and let others in. Working big is BIG work. Fresh eyes are key when it comes to staying inspired and in touch with your piece. When doing a collaborative piece, use your break from creating to allow a new contributor to step up to the canvas. Not all creators are artists by nature. To really watch a piece unfold and come to life in an organic and enlightening way, gather these nonartist creators to join you when working big. Encourage these creators to add layers that are unique to them as a person.

Working big will require covering things up. You will be adding and subtracting to your piece on a completely new level. Each time you invite a new member of your creative clan to add their fingerprint to your canvas, you are stretching as an artist. By allowing others to step up to your canvas, you are letting go of the visionary control that we all, as artists, hold near and dear to our hearts.

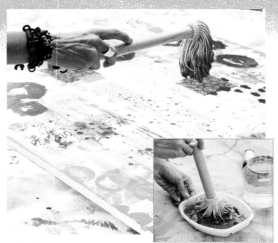

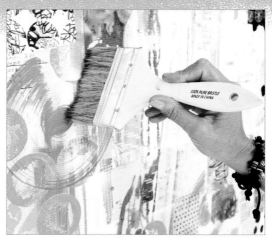

10 Get your artwork horizontal. Viewing your piece from overhead will allow you to see your canvas from a bird's eye view. Create new marks that won't drip when applied. Dip a reclaimed BBQ mop brush into a mixture of acrylic ink and water. Saturate the brush well and gently rock the handle in a drumstick-like motion over the surface of the canvas to splatter the ink. Let the ink dry.

11 Once the ink has dried, load your palette with a heavy-body acrylic paint. Tap the bristles of a large chip brush into the paint several times to heavily load the tips. Place the brush onto the canvas and in one fluid motion twirl the brush into a loose circular shape. Let the brush bump and skip across the surface to create hoop-like prints that are more organic in nature.

» Make Your Mark: A Tip «

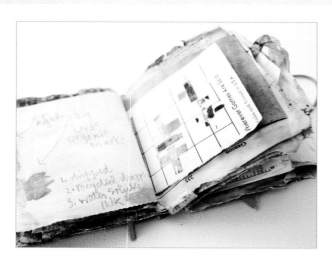

As you create, refer to your art marks journal. Use the notes you made as a reference, reshaping and rescaling your marks as you work big.

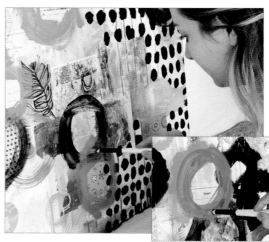

12 Get low when you work. Sitting, rather than standing, in front of a large canvas will limit your reach and encourage you to work within the smaller confines of your view. Build upon the marks that your collaborators have added to the canvas before you by replicating similar marks using additional colors. Ring the collaged papers to anchor them to the panel and join them together.

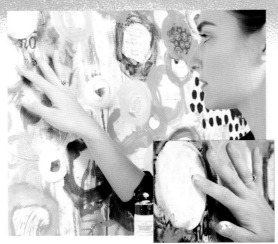

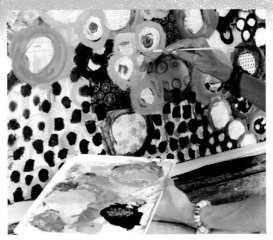

13 As you leaf through your journal for inspiration, think about the texture and dimension that using your own built-in tools can offer. Your fingers are the perfect brush for layering on thick, painterly strokes. For added depth, let the paint rest or use your fingers to further work the paint into the surface of the canvas. Working the paint creates a semiopaque layer over your collage pieces.

14 Use a smaller round brush to paint a series of concentric circles. Before the paint dries, use the same brush to swipe the center of the circles, blending each circle into a soft abstract rosette shape. Flip and rotate your canvas often to view your panel from a new perspective. Take several shapes off the edge and continue to blend each new layer together with the previous ones as you add marks.

You Got This!

Be inspired by your co-creators. Use their marks as a springboard for your own, and work to make the canvas a truly collaborative piece of art. By choosing to create together, you are agreeing to learn from one another. The very marks themselves aren't what make a signature style, but rather the way the artist imparts the mark onto the canvas. Each flick of the wrist or twist of the brush defines your mark from your co-creators. Creating side by side opens up a world of untapped inventiveness. Experiment with the marks of another creator, adapting them to reflect your own unique style, and in doing so, fine-tune your artistic fingerprint.

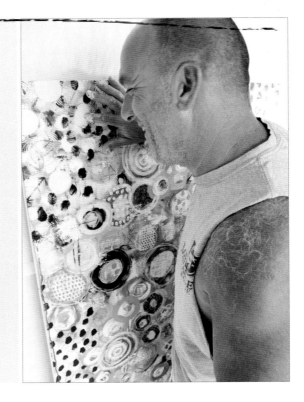

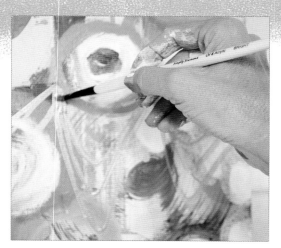

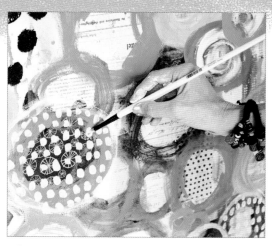

15 As you continue to add marks, think about your line work. It is a key element in your Working Big project and has the power to ground an image and create eye-catching details. Hinge your line work by connecting it to the edge of your canvas or other large components of your piece. Repeating line work is simple to create and can add a bit of charm and whimsy to your artwork.

16 Layer your small marks over existing shapes and paper elements. Use an assortment of small flat and angled brushes to create imprints that are irregular and organic in shape. Adding dots and dashes over abstract prints and repeating patterns adds the illusion of depth to your work. Use your collage paper as a springboard for the series of marks you will create.

Art and composition tolerate no conventional fetters: mind and soul soar above them.

—JOSEPH HAYDN, 1779

17 The concept of layering will begin to emerge fully as you repeat the techniques first applied to your Working Big canvas. Fill a dropper with acrylic ink and use it to sketch a series of scallops along the top edge of your canvas, gently squeezing the dropper bulb as you draw. Allow the saturated tips of the scallops to drip, and once dry, fill in any negative spaces with acrylic paint.

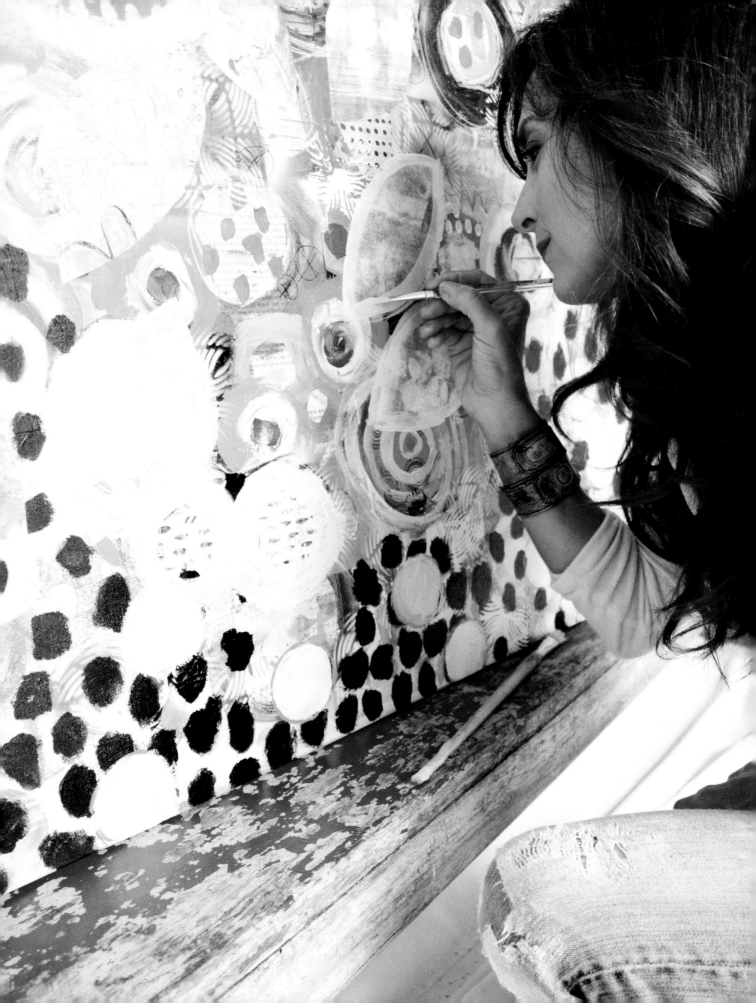

18 Trim a new ring-shaped piece off the end of your foam pool noodle. Cut the ring in half again, creating an arc-like stamp. Add three similar hues of paint to your palette and pounce the stamp in the paint mixture to meld the colors slightly. Load the stamp with paint and begin to print your canvas with the foam. Layer the impressions as you go, creating an ombré-hued effect.

19 Working big doesn't mean forgoing tiny details. It is in these minuscule marks that the viewer finds hidden meaning and interest. Use your favorite pens and pencils to add several small knots of tiny marks. Turn your canvas and encourage your co-creators to add their own minute features to the canvas, each of you adding your own unique signature to the artwork.

You Got This!

For all art, big or small, learning to allow yourself the freedom to create uninhibited by the boundaries of right and wrong brings into being a joy for the artistic process that can only be achieved through making art you love. For some, that will mean mastering their skills in a traditional and routine manner, becoming capable of each new technique before attempting the next; for others, they learn proficiency as they go, working their brush into an unorthodox frenzy of color and marks until they are happy with what they see.

20 As your canvas nears completion, you will recognize something in the work as your own and you will want to control the path it takes. Let go of that control and trust the other collaborators to add marks that feel right to them. Large paint-dipped tubes will add delicate and unstructured halos to your repertoire of marks. Group several overlapped rings into small areas of your canvas.

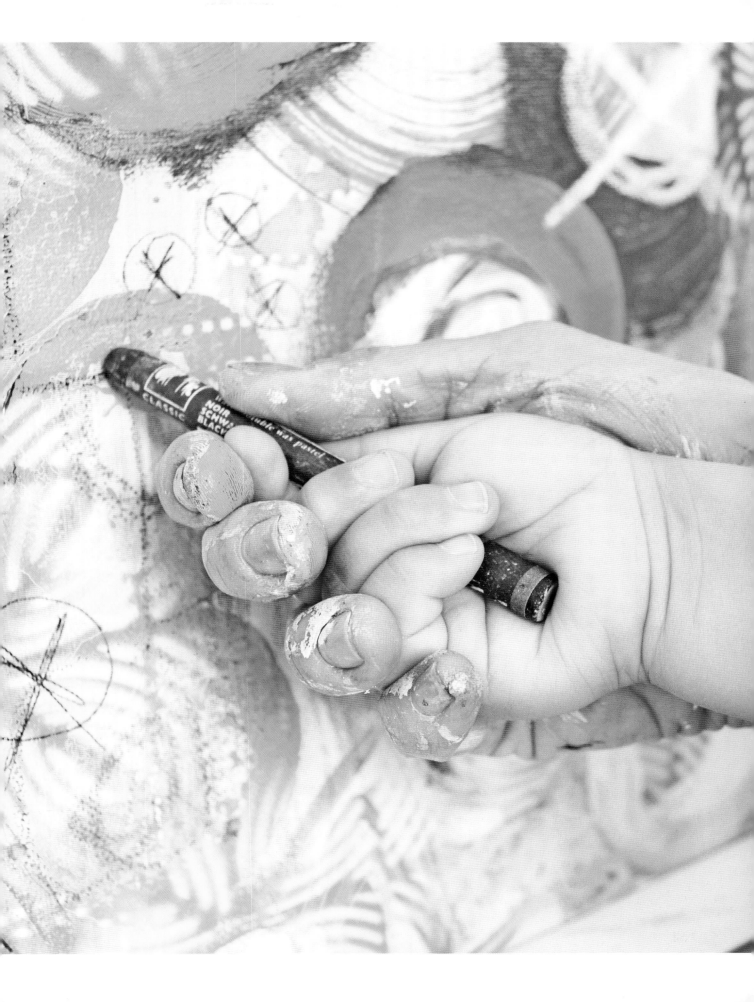

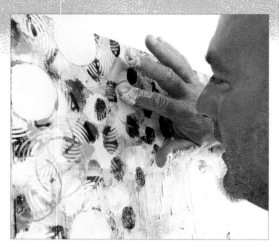

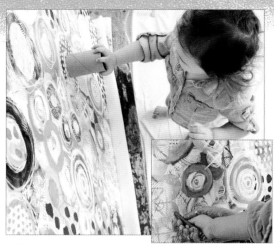

21 Choosing co-creators who rarely or never make art adds an element of surprise and wonder to your clan collaboration. Try to resist guiding them in their marks and, instead, encourage these budding artists to get messy and do what feels right. Finger painting is a fun technique that everyone can enjoy, and it's great for getting a final layer of texture onto your oversized artwork.

22 Invite even the youngest co-creators to add their fingerprint to your Working Big canvas. They have a rare and keen perspective on the project and will not be easily guided, allowing true organic shapes to take form as they put crayon or brush to canvas. Let each tiny hand choose its own tools and work with them as they experience the look and feel of each one in their grip.

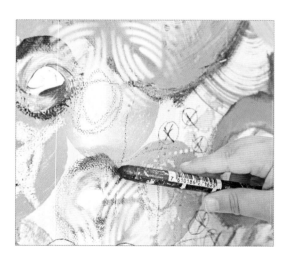

23 Just as you might feel comfort in working alongside a counterpart, so will your tiny co-creators. Let them join together as they choose from a wide range of tools, then consider letting them play with them a bit before introducing the concept of paint or ink. Once they are comfortable with their instrument of choice, remind them that no space is off limits and let them step up to the canvas.

24 Anchor your big canvas. Use collage pieces to add one final and oversized focal point to your Working Big project. Cut collage pieces and use removable tape to place them on your canvas until you are happy with the layout. Finish by adhering them with gel medium and outlining them with paint. Add a few scribbled notes about the process in the form of journaled words.

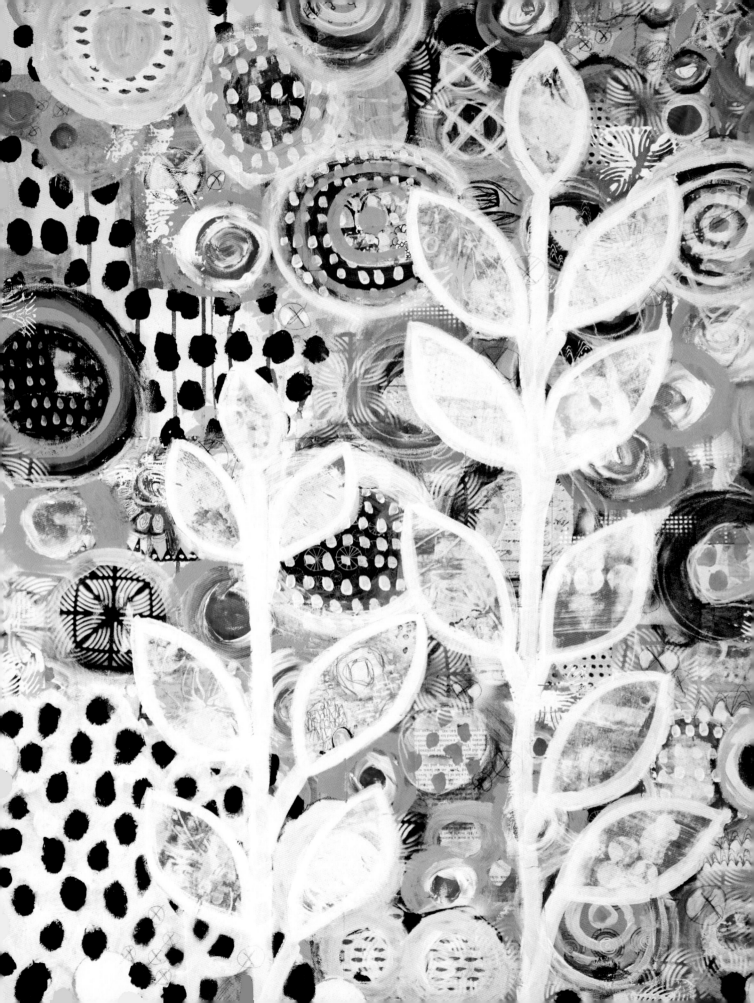

Index

Dedication

TO FELLOW MARK MAKERS EVERYWHERE.
WE ARE, INDEED, ARTISTS IN OUR OWN RIGHTS.

Acknowledgments

This book has been on my bucket list for as long as I can remember. I have written it many times in my head, and now it emerges onto paper in a form so different from what I envisioned, yet just as lovely.

With deep gratitude, I acknowledge my best friend and soul mate Carl, whose unending love and encouragement gave me the courage to take this giant leap forward.

To my uplifting and spirited daughter Camille for her undivided attention when all things important were placed before me, and I needed both guidance and clarity.

To my parents, who pushed me and made it possible for me to do all the things growing up that helped shape me into the creative soul I am today.

To my big, chaotic, happy clan, all of whom are bright, witty and amazingly talented: my daughters Gabi, Livvie, Sophia and my son Ethan for always making me feel like I have created genuine masterpieces, never to be replicated on any canvas. To my sweet grandbabies Lincoln and Goldie, who made writing this book both a challenge and a greater reward for having completed it with them both in tow.

To my friend Sandi for always reminding me that I can say "no" and for kindly supporting me when I choose to say "yes."

To my editor, Amy Jones, for her kindness, honesty and forthright encouragement, thank you for believing that I could write this book. You always made time to talk and made me feel like a pro even when I felt like much less. And to Tonia Jenny for always cheering me on and making sure I began this endeavor with all the tools I needed to make this book a success.

And to you, kind and faithful readers, thank you for allowing me to share my unique fingerprint with you and for encouraging me with your ever-flowing wave of kind words of support.

About Rae Missigman

RAE MISSIGMAN, MIXED-MEDIA ARTIST, AUTHOR AND INSTRUCTOR
loves to share her design passions in the classroom, on the printed page and on her website. No ordinary object is safe in her hands but is destined to become something extraordinarily beautiful and wildly imaginative.

Rae's mantra is no piece is complete without layers of her signature marks, dots and dashes. Her large following of art lovers clamor for her books, products and instructional videos to bring repetitive marks into their own art journals.

Rae's color palette is bold and vivid despite her professed love for the color white. She finds white soothing in her personal life and the perfect backdrop for the splashes of color dominating her pieces.

Rae works from her often-photographed home studio in central Florida where she lives with her supportive husband and five children, and where she now passes her love of color and design on to her grandchildren.

You can find Rae on social media at:

WEBSITE: raemissigman.com
IG: raemissigman
FB: Raemissigman
TWITTER: @Raemissigman

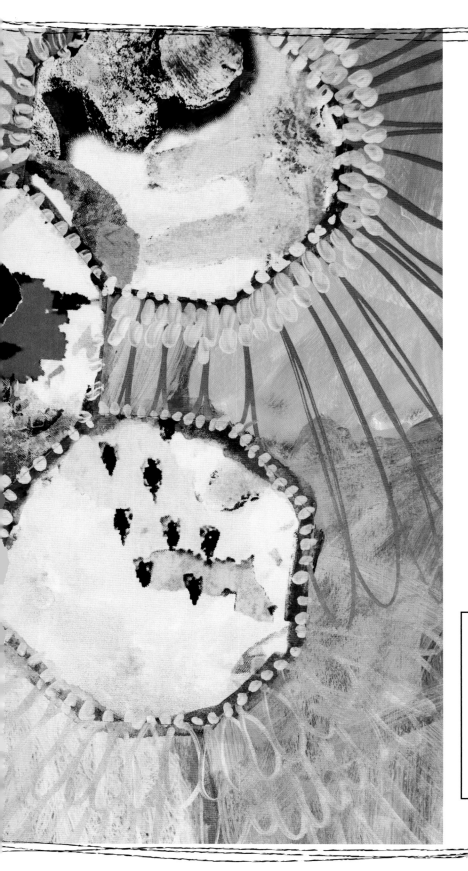

a content + ecommerce company

Other fine North Light books are available from your favorite bookstore, art supply store or online supplier. Visit our website at fwmedia.com.

22 21 20 19 18 5 4 3 2 1

DISTRIBUTED IN THE U.K. AND EUROPE BY F&W MEDIA INTERNATIONAL LTD
Pynes Hill Court, Pynes Hill, Rydon Lane, Exeter, EX2 5SP, UK
Tel: (+44) 1392 767680
Email: enquiries@fwmedia.com

ISBN 13: 978-1-4403-5028-3

Edited by **TONIA JENNY AND AMY JONES**
Production edited by **JENNIFER ZELLNER**
Cover Design by **JAMIE DEANNE**
Interior Design by **CHARLENE TIEDEMANN**
Production coordinated by **DEBBIE THOMAS**

METRIC CONVERSION CHART

To convert	to	multiply by
Inches	Centimeters	2.54
Centimeters	Inches	0.4
Feet	Centimeters	30.5
Centimeters	Feet	0.03
Yards	Meters	0.9
Meters	Yards	1.1

Ideas. Instruction. Inspiration.